IMAGES
*of America*

# NEW HAVEN
# FIREFIGHTERS

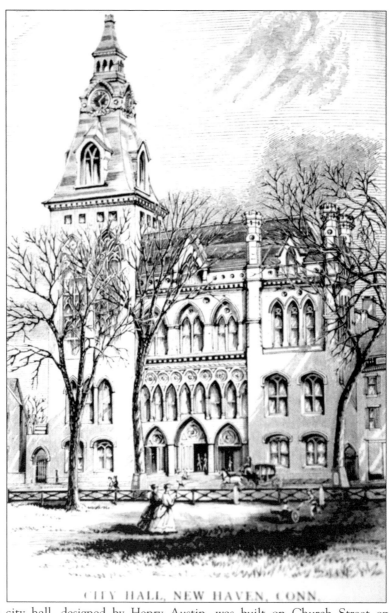

CITY HALL, NEW HAVEN, CONN.

The new city hall, designed by Henry Austin, was built on Church Street opposite the marketplace that is known today as the New Haven Green. The dedication of the structure with the 150-foot-high clock tower occurred on October 6, 1862, the same year that the paid full-time fire department was organized. In the early years, the offices of the fire chief engineer and subsequently the fire marshal, conducted their administrative duties here. The tower also housed one of the fire department bells, which was rung to signal a fire in progress. Throughout the history of the New Haven Fire Department, this imposing structure is where many of the decisions affecting the organization of the fire service were made. It is where the Board of Fire Commissioners held its meetings, and it also housed the chambers of the Board of Aldermen. After the Connecticut General Assembly enacted the Municipal Employees Relations Act in 1965, negotiations for the first collective-bargaining contract between the city of New Haven and New Haven Firefighters Local No. 825 were held in this building.

# IMAGES
## *of America*

# NEW HAVEN FIREFIGHTERS

Box 22 Associates

ARCADIA

# Box 22 Associates Book Committee

# CONTENTS

I am more powerful than the combined armies of the world. I have destroyed more men, women, and children than all the wars of all nations. I massacre thousands of people every year. I am more deadly than bullets, and I have wrecked more homes than the mightiest guns. In the United States alone, I steal over $500 million each year. I spare no one and I find my victims among the rich and the poor alike, the young and old, the strong and the weak. Widows know me to their everlasting sorrow. I loom up in such proportions that I cast my shadow over every field of labor.

I lurk in unseen places and do most of my work silently. You are warned against me, yet you heed me not. I am relentless, merciless, and cruel. I am everywhere—in the home, in the schools, in the factory, on land, in the air, and on the sea.

I bring sickness, degradation, and death, yet few seek me out to destroy me. I crush, I maim, I devastate—I will give you nothing and rob you of all you have.

I am your worst enemy. I am rampant fire.

# INTRODUCTION

here probably is in reality no group of people who have touched the lives of so many, more than he firefighters of America. The long, proud history of the New Haven Fire Department dates ack to December 29, 1789, when Roger Sherman, New Haven mayor and a signer of the Declaration of Independence, formed the volunteer system. The volunteers served gallantly, nder somewhat primitive conditions, until Mayor Harmanus M. Welch, in his annual address n June 3, 1862, noted the need to change the business of fighting fires. That was a significant eriod of time in the history of the city of New Haven. It marked the end of the volunteer system nd the beginning of the paid fire department, with the advent of the steam engine. It was also period of war as the Union and the Confederacy clashed in a divided nation.

Box 22 Associates was founded in 1932 by a group of prominent businesspeople and rofessionals who found a common interest in the New Haven Fire Department. During that ra, members of the group hung out at fire stations and showed up at a fire no matter the time f day. Today the primary purpose of Box 22 Associates is to provide an emergency canteen ervice at major fires, sponsor a Firefighter of the Year award, participate in parades, and reserve the memorabilia and heritage of the New Haven Fire Department.

New Haven has a long and proud history of tradition in its fire service. Since 1862, over the ist 142 years, only 15 different chiefs have headed the department. Many stories of the past ave been related from generation to generation. Sadly, the ranks of the "old timers" have hinned out. Memories of the past must be preserved to tell the story of the heroics and bravery f so many who have protected the streets of New Haven from the ravages of fire.

In order to photographically tell the story of the oldest paid department in Connecticut, we ave formed a committee within our organization to share resources, research archives, and btain additional photographs and news articles that had been hidden away in scrapbooks and ttics. We choose to focus on the beginning of the paid department, in the period from 1862 hrough 1990. To capture this era in 128 pages was a challenge worth pursuing. Our seven hapters feature more than 200 photographs and postcard images.

The photographs in this book have come from many sources. Outside of the main members f the committee, who have compiled albums and scrapbooks for years, we have obtained hotographs from media photographers (some of whom are now deceased), fire buff hotographers, the Department of Photography of the New Haven Fire Department (NHFD), he New Haven Fire Department Training Academy (NHFD/TA), the New Haven Colony

Historical Society (NHCHS), widows and relatives of deceased firefighters, retired firefighters officers, and friends.

The book features pictures of many fire stations, some of them no longer in existence. There are numerous action photographs taken at major fires and a sprinkling of tragic photographs c firefighters, as in the Wild West, dying with their boots on. The New Haven Fire Department' most historic site is the Firemen's Monument, which was dedicated in 1877 at Evergreen Cemetery. This huge statue is on a burial plot owned by the New Haven Firemen's Benevolen Association. The monument was rededicated in 1993 in a similar manner to the origina unveiling. The Benevolent Association continues to operate under its charter issued in 1849.

Tragically, New Haven has the unwanted distinction of having the most firefighters die in the line of duty among Connecticut fire departments. Through research, we have found that 59 men have made that supreme sacrifice, many of them dying a violent death. We dedicate this book to their everlasting memory.

There are many events that are etched in time and in some cases caught by the snap of the photographer's hand and eye. We have attempted to research and retrace accurately all the pictures we have collected that are part of this historic book. It was important to the committee to identify, where possible, all the faces shown in the photographs. Hundreds of firefighters who have passed through time over the past seven decades have sacrificed much to enrich the live of so many. It would be impossible to record every happening with a photograph, because, in fact, many of those events were not captured on film.

In our quest to research the origin of each photograph, it was necessary to visit the Sterlin Library at Yale University, many times, scrolling through microfilm of newspapers such as the *New Haven Union*, *New Haven Palladium*, *New Haven Evening Leader*, *New Haven Journal Courier*, and *New Haven Register*. Many of the journalists of past eras never had the recognition of a byline, nor the photographers, their name credited with a photograph.

Over the years, many of these images have been passed on to members of the fire service by the photographers who braved the elements and the dangers at the fire scene. Their work has preserved an important part of history. The late Charles T. McQueeney, managing editor of the *Register*, made it a point—without question—to send photographs, after they were published to many of the firefighters. We made an effort to credit every photograph properly identified to the photographer.

We wish to thank all who contributed to this book in any way. A special thanks to James Campbell and Amy Trout of the New Haven Colony Historical Society, who guided us through the archives. We thank postcard collector Joe Taylor for sharing his rare fire service cards. We acknowledge the cooperation of Fire Chief Michael Grant and Capt. William Seward, director c training, for the use of the department library resources and history files. A large portion of the photography has been the work of retired Deputy Chief Alfred Bysiewicz (1951–1985), who headed up the Department of Photography. Dorrance Johnson, a member of our committee, ha archived and rephotographed many of the images shown in this publication. Chan Brainar resolved some of our photograph research information all the way from his home in California. In conjunction with this project, committee member Lt. Matthew Marcarelli has developed a Web site for Box 22 Associates (www.box22.org) that is filled with many historic facts and photographs

This trip down memory lane traces the progress in time of the dedicated men and women o the New Haven Fire Department.

—Edward F. Flynn Jr. and William C. Celentano J
Book Committee Co-chairmen
August 31, 200

# One

# A NEW BEGINNING

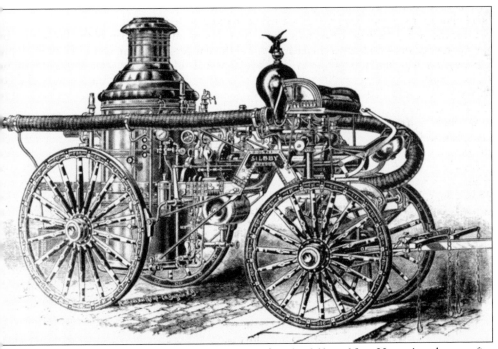

The arrival of the first steam fire engine on December 6, 1860, to New Haven's volunteer fire department marked the beginning of the end for the old system. The engine became Steamer Company No. 1, assigned to the station at 108 Congress Avenue. On May 21, 1862, Steamer Company No. 2 went to the Artizan Street station, as the city government slowly disbanded the volunteer companies and became an all-paid department. (Courtesy of NHCHS.)

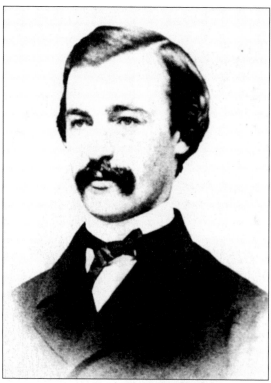

The inaugural meeting of the new Board of Fire Commissioners was held on June 17, 1862, with Mayor Harmanus M. Welch presiding. Charles W. Allen, a former chief engineer of the volunteer department who had just returned from serving with the 2nd Regiment, Connecticut Volunteers, in the Civil War, was chosen chief engineer of the New Haven Fire Department on June 24, 1862. The volunteer companies were disbanded on July 1, and Allen continued as chief engineer until July 8, 1865. (Courtesy of NHCHS.)

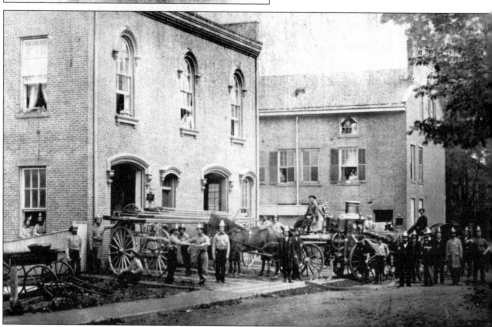

H. M. Welch Steam Fire Engine No. 2 and Mutual Hook and Ladder No. 1 stand outside their station on Artizan Street. The art of photography was in its early stages of development when this picture was taken in 1864. It was then common to name fire apparatus after individuals. Also in that era, firefighters could live in the stations they were assigned to, as long as they received permission from the chief engineer and abided by strict rules and regulations.

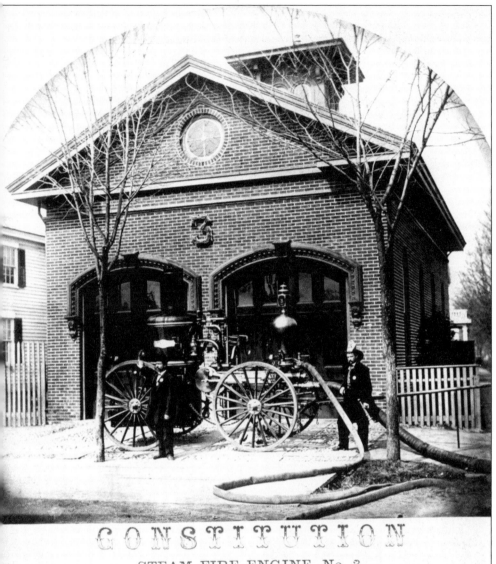

CONSTITUTION

STEAM FIRE ENGINE. No. 3.

GEO. M. HOBART, Engineer.    NEW HAVEN, CONN.    CHAS. M. HALL, Foreman

Constitution Steam Fire Engine No. 3, a Portland machine drawn by two horses, was purchased in May 1861 at a cost of $2,800. Its firehouse, at the corner of Park and Elm Streets, was built in 1861 and cost $3,678.67 fully furnished. A four-wheel hose carriage with 1,000 feet of hose, drawn by one horse, was also assigned to the station. In the summer of 1862, post fire hydrants with two openings and a four-inch valve were in place and provided a good supply of water to the steamers. Members of the company slept in bunks on one side of the engine house floor to be near the apparatus in case of fire calls during the evening hours. To remedy the unhealthy conditions the firefighters faced by residing so close to the horse stables, a second floor was added to the station in 1865 to provide comfortable sleeping quarters for the men.

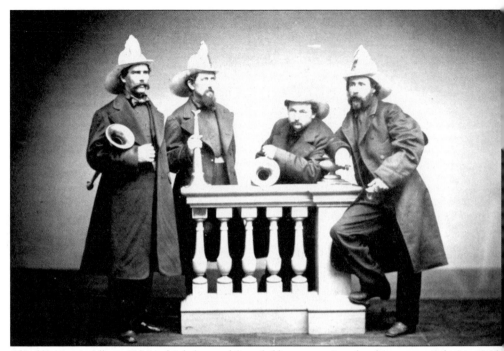

Chief Engineer Albert C. Hendrick (second from left) was appointed to his post on July 24, 1865. He is pictured here with his three assistants: 1st Assistant James W. Walter (far left), 3rd Assistant Charles C. Hall (third from left), and 2nd Assistant George W. Corbusier. Members of the Board of Fire Commissioners were Gardner Morse, Marcus M. Rounds, Edward Bryan, B. H. Douglas, John H. Leeds, and Lewis Elliott Jr. The first review and inspection of the department under the new system took place on September 27, 1865. (Courtesy of NHCHS.)

This special badge was presented to Chief Engineer Albert C. Hendrick, who was highly respected for his knowledge and ability to lead the fire department in the early years. Hendrick was a very popular figure in the city government. When he rode off to fires in his horse and buggy, he always attracted an audience. There is a special display of memorabilia left by Hendrick at the New Haven Colony Historical Society. (Courtesy of Wooster Lodge No. 79, Ancient Free and Accepted Masons.)

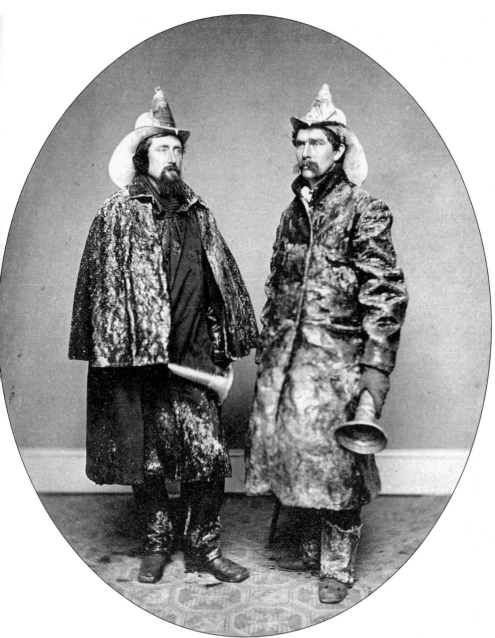

According to the *New Haven Palladium*, on January 15, 1867, a fire broke out in a large wooden double house on Congress Avenue near Lafayette Street. The blaze destroyed three stores, a barbershop, a saloon, and the West Congregational Church, which held its services upstairs. Four families that resided on the upper floors managed to escape into the freezing weather, clad in their night clothes. Chief Albert C. Hendrick (left) and 1st Assistant Chief James W. Walter (right) directed the firefighters. The *Palladium* stated, "The firemen worked, as they always seem to, with the greatest alacrity, notwithstanding the severity of the weather. Some of them were glazed with ice from head to foot during their labors." After several hours at the fire scene, Hendrick and Walter managed to have this picture taken at the W. A. Beers National Gallery on Chapel Street. (Courtesy of NHCHS.)

BADGE OF THE FIRE DEPARTMENT.

In 1868, the newly adopted badge of the fire department replaced the old badge, which had been in service since 1858 during the volunteer era. It was referred to as the "pie plate" badge. At the same time, the permanent members of the department purchased (at their own expense) a blue cloth regulation cap in a style similar to the U.S. Navy cap. Also that year, the department installed the Gamewell system of fire-alarm telegraph. (Courtesy of NHCHS.)

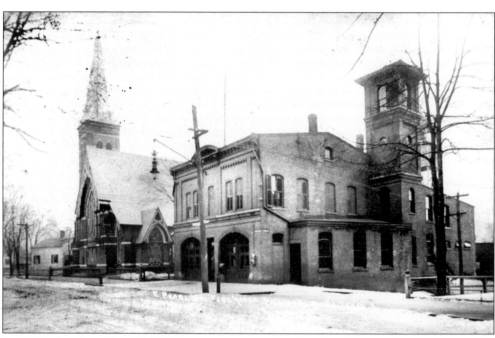

In 1870, after the village of Fair Haven was annexed to the city, this new fire station rose the following year on the corner of East Pearl and Pierpont Streets. John H. Leeds Steam Company No. 5 and Quinnipiac Hook and Ladder Company No. 3 were placed in service there to serve the Fair Haven area. It was also the year when gongs were placed on all steamers to warn people of approaching fire apparatus. (Courtesy of Joe Taylor.)

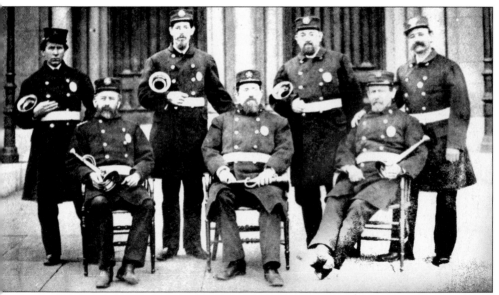

This rare photograph of the fire department's top echelon, taken outside city hall on Church Street in 1877, depicts the department's leadership in the early years. From left to right are the following: (sitting) Leonard I. Bassett, assistant engineer; Albert C. Hendrick, chief engineer; and Andrew T. Kennedy, fire marshal and assistant engineer; (standing) Charles C. Denison, assistant engineer; William H. Hubbard, assistant engineer; John L. Disbrow, assistant engineer; and James A. Wilkinson, superintendent of fire alarm and telegraph. (Courtesy of NHFD/TA.)

At a meeting held on July 18, 1879, at city hall, the city's former volunteer firemen met and organized the Veteran Volunteer Firemen's Association. Elected as the group's president was Hiram Camp, a former chief engineer who was one of the original fire commissioners when the paid department took over in 1862. Camp was also president of the New Haven Clock Company, which he founded in 1853. (Courtesy of NHCHS.)

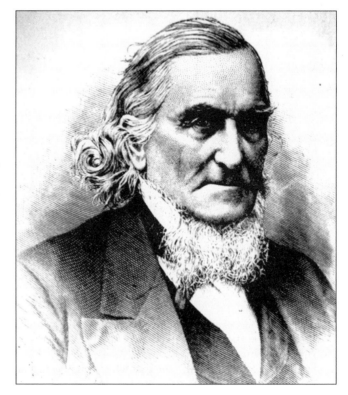

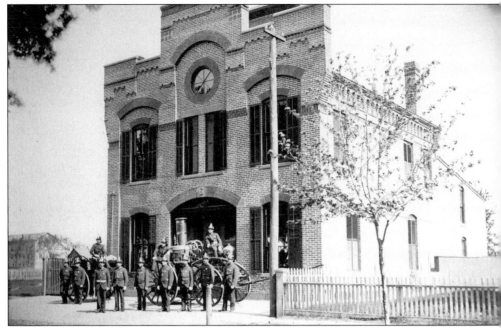

The Division Street station (pictured *c*. 1883), home of Steamer Company No. 6, was located a long distance from any other fire station. When the volunteer system was abandoned in 1862, the company served the city as the only remaining volunteers manning a hose cart. Eventually the Division Street unit became a paid company as the growth of the city expanded to the northwest. (Courtesy of NHCHS.)

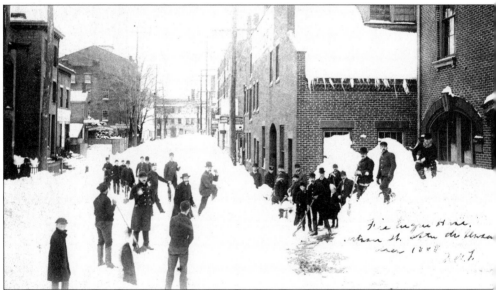

When a blinding snowstorm arrived during the second week of March 1888, it was called the Blizzard of '88. The storm had formed in the Dakotas and moved eastward, dumping snow at a furious pace, accompanied by howling winds that blew for hours and hours. After the storm, firefighters from the Artizan Street station spent the day digging out, but they did pause long enough for a photo opportunity amidst the mounds of snow. (Courtesy of Joe Taylor.)

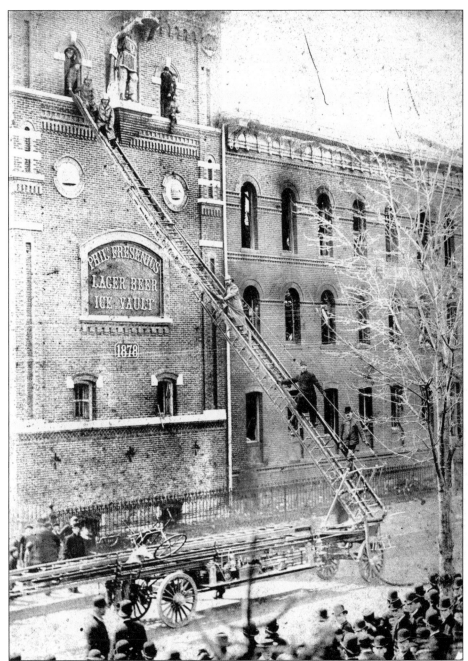

The brewery known as Philip Fresenius Lager Beer Ice Vault burst into flames at 2:00 a.m. on April 15, 1888. After examining the fire damage the next morning, officials and commissioners of the fire department took the time to pose on the raised aerial ladder to have their picture taken. Assembled at the Congress Avenue scene is a large crowd of folks dressed up in their Sunday best. Firefighters continued to wet down the smoldering interior of the brewery, which had been gutted by the fire. Several horses were rescued from the building. Discarded hot ashes were the cause of the blaze, which had spread rapidly due to the presence of tinder-dry old barrels, wooden bungs, and grain bags. (Photograph by A. Bowman.)

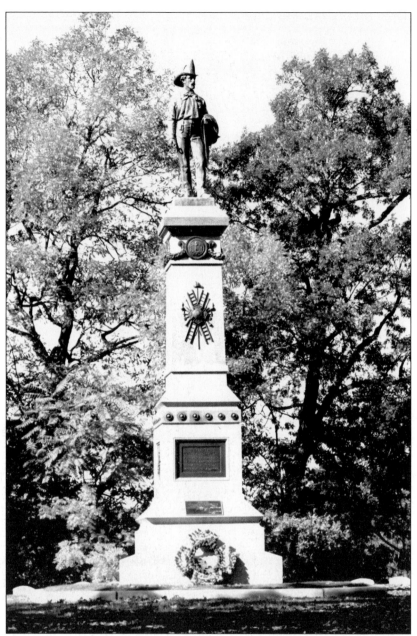

On July 9, 1877, the Firemen's Monument was dedicated at the Evergreen Cemetery on Winthrop Avenue. The New Haven Firemen's Benevolent Association, chartered in 1849, had purchased the imposing structure to honor all deceased firefighters. Officers, firefighters, and members of the old volunteer system joined with city officials and invited guests at the assembly in front of city hall. A procession was led by Chief Albert C. Hendrick and Mayor William Shelton, and the 21-piece American Band escorted the delegation to the cemetery. Fire chiefs from Springfield, Middletown, South Norwalk, and Fair Haven (East) proceeded on foot to the cemetery. The procession was joined by a large number of spectators who gathered around the monument, undeterred by the falling rain. John H. Leeds, fire commissioner emeritus, was the keynote speaker. (Photograph by Michael Vanacore.)

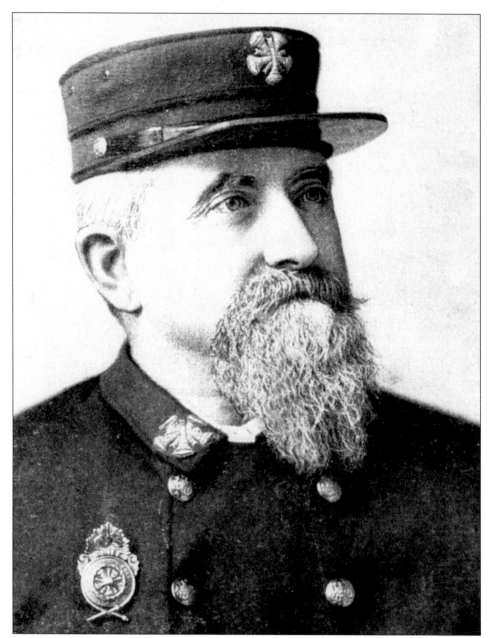

Albert C. Hendrick was chief engineer from 1865 until January 31, 1892. When he took over the helm of the New Haven Fire Department, it was still in its early years of organization. The department was poorly manned, insufficiently equipped, and had inadequate housing for the men and apparatus. During Hendrick's 26 years as chief, the department was the first to avail itself of new innovations. Its use of the fire-alarm telegraph system became a model for other fire departments to follow. Hendrick fought in the Civil War with the 12th Connecticut Volunteers and took part in the capture of New Orleans. He was president of the International Association of Fire Engineers in 1875 and also served as president of the Connecticut State Firemen's Association from 1886 through 1888. In 1895, Hendrick took the oath of office as the 32nd mayor of the city of New Haven. (Courtesy of NHCHS.)

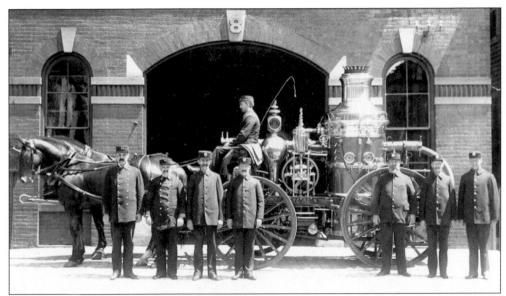

Pictured *c.* 1897 is the Steamer Company No. 8 station at 19 Edwards Street. The company's Jeffers steam fire engine was delivered with the opening of the firehouse in 1874. The men originally assigned to the station were William H. Bishop (engineer); Allen Renfrew (engine driver); Augustus Island (hose driver); Samuel Woolcot (stoker); James J. Bradnack (foreman); William H. Merwin (assistant foreman); and Henry Smith, James Clerkin, Benjamin Graham, Charles Klippstein, Herbert Clark, W. Edward Thompson, P. H. Rohan, and David Renfrew (hosemen).

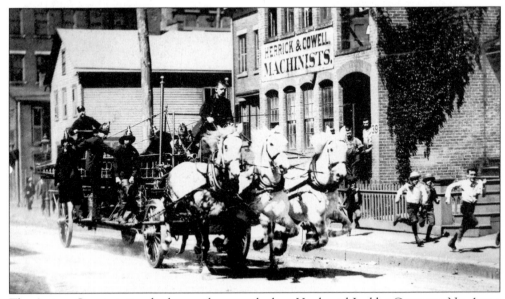

The Artizan Street station had recently opened when Hook and Ladder Company No. 1 was summoned to an alarm in 1894. As the unit raced to the scene, a group of youngsters ran alongside the horses, named Tom, Dick, and Harry. The boy in the white hat, Herbert Hotchkiss (a local fire buff), identified the men on the rig as Charles Page, William Miller, Capt. Rufus Fancher, William Perkins, Charles Chapman, Charles O'Neill, and Joseph Condren. (Courtesy of NHCHS.)

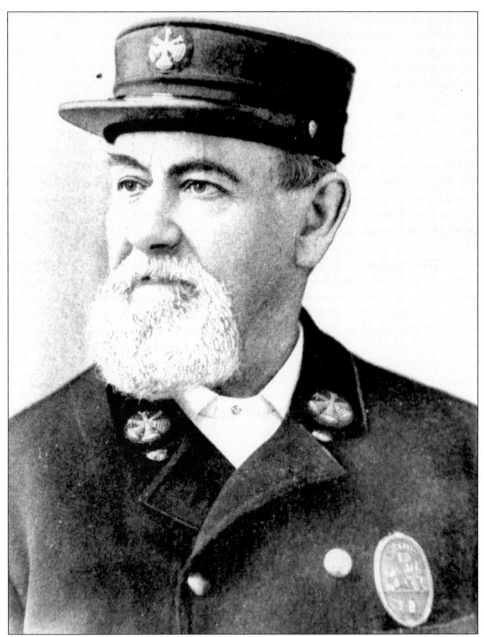

In 1874, Andrew J. "King" Kennedy became the fire marshal and assistant chief. As marshal, he carved out a long and honorable record of 18 years of enforcement of municipal fire regulations. Kennedy was highly praised for his leadership after the fires in the New Haven Wheel Shop in 1874 and the Candee Rubber Company plant in 1877. One of the most notable characteristics of his method in handling a fire was the clearness with which he gave his orders. Every firefighter and citizen could hear Kennedy's commands over the crackle and roar of flames and the hissing of hose and engines. He was appointed chief engineer on February 1, 1892. However, Kennedy's aggressive leadership tactics resulted in his sustaining painful injuries when he fell through an elevator shaft at a fire in Cullom's Carriage Shop on Franklin Street. He retired from the department on September 3, 1897. (Courtesy of NHCHS.)

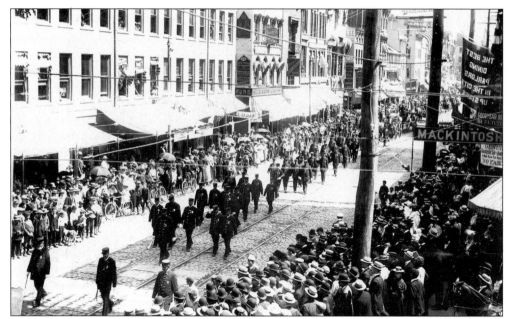

The 25th anniversary of the International Association of Fire Engineers was celebrated in New Haven during the summer of 1897. The grand festivities culminated in a parade of hundreds of firefighters, steam engines, hose tenders, and horse-drawn carriages. Thousands of spectators and visitors to the city viewed the long parade in awe. A sea of firefighters moved through the parade route down Chapel Street, to Church Street, to the reviewing stand in front of city hall. New Haven Fire Chief Andrew Kennedy was instrumental in bringing the convention to the city. His connections with the International Association of Fire Engineers earned him worldwide fame, and in 1897 he was elected president of that organization. (Courtesy of NHFD/TA.)

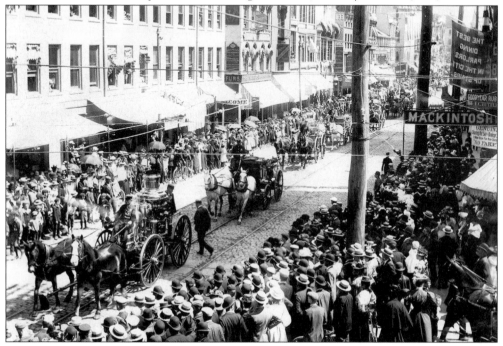

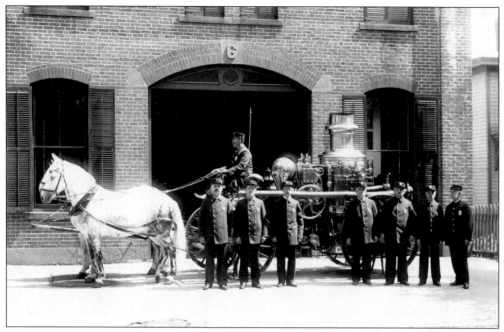

Two of the New Haven units in the parade are pictured in front of their stations. Above, Steamer Company No. 6, equipped with third-size Hunneman engine, carried three men and weighed 6,000 pounds. Joining the company was a two-horse hose wagon carrying 1,000 feet of hose. Capt. Wilfred F. Spang and Lt. Sylvanus Gesner were the officers in charge of this unit. Below, Steamer Company No. 7, stationed at Water Street, was equipped with second-size Silsby rotary steam engine, carried three men, and weighed 8,000 pounds. A two-horse hose wagon was assigned with the steamer. Officers in charge were Capt. William B. Perkins and Lt. Christopher T. Langley.

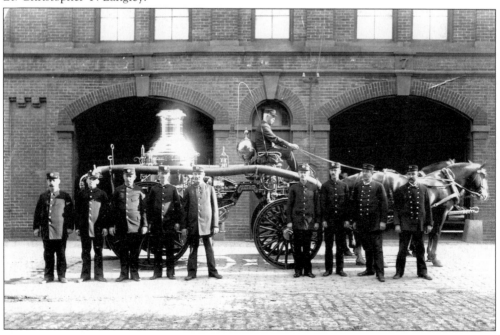

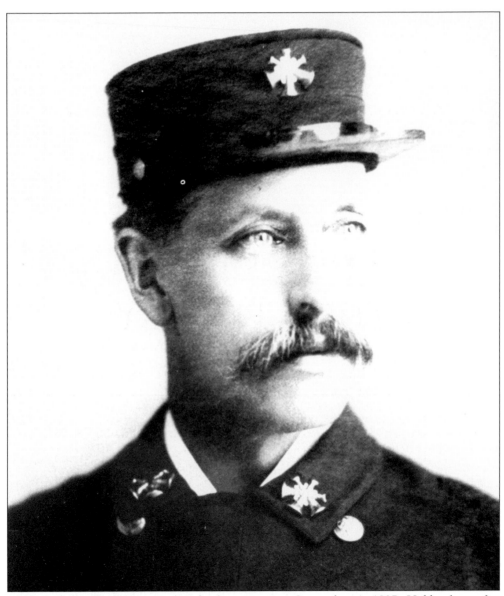

William H. Hubbard became the chief engineer on September 4, 1897. Hubbard was fire marshal and assistant engineer, with close to 30 years of service, when he was tapped to lead the department. In 1862, when Hubbard was just 17, he had responded to President Lincoln's call for 300,000 additional Union soldiers by enlisting as a private in Company I, 15th Connecticut Volunteer Infantry. During Hubbard's three years of service he had fought with his regiment in the Battle of Kingston, North Carolina, but while nearly all of his fellow infantrymen were captured there, Corporal Hubbard succeeded in eluding the enemy. He received an honorable discharge on June 27, 1865. Hubbard went on to serve with Hose Company No. 1 in 1867. He became a hoseman with Steamer Company No. 1 in 1869 and became a permanent captain of Steamer Company No. 2 at the Central Station in 1885. Hubbard experienced failing health just a year after he became chief engineer, so the Board of Fire Commissioners granted him a leave of absence. On August 29, 1898, Hubbard died in Philadelphia. (Courtesy of James Boyle.)

# Two
# THE TURN OF
# THE CENTURY

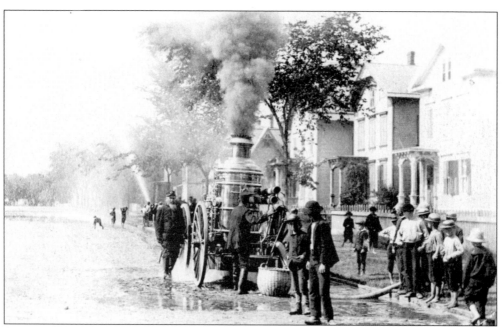

Steamer Company No. 5, equipped with a third-size Jeffers steam fire engine, drew a large crowd of youngsters in the Fair Haven neighborhood during a 1901 training session. In this scene, smoke bulges out of the steamer as the stoker feeds the fire with a fresh shovel of coal to ensure adequate pressure for a solid stream of water from the hose nozzle. The steamer rode out of the East Pearl Street station.

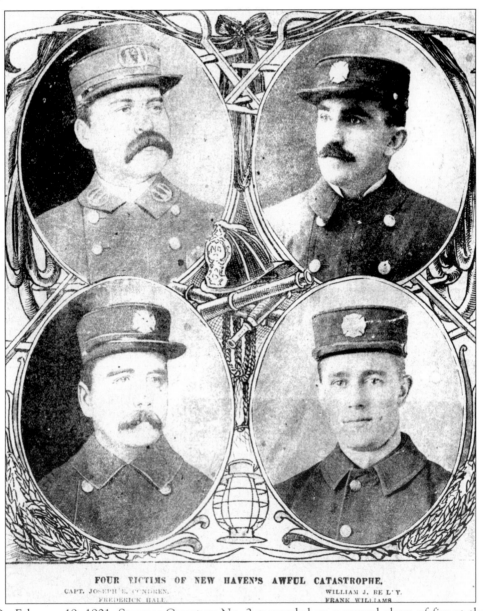

FOUR VICTIMS OF NEW HAVEN'S AWFUL CATASTROPHE.

CAPT. JOSEPH E. CONDREN.          WILLIAM J. RE L'Y.
FREDERICK HALE.                    FRANK WILLIAMS.

On February 19, 1901, Steamer Company No. 2 responded on a second alarm of fire at the vacant Judson Packing House, located between Winchester Avenue and the old Canal Road. Tragically, four members of the unit died when a wall of brick, mortar, and flaming timbers came crashing down on them. While they were battling the fire, the men had moved closer to the building and a doorway to direct a stream of water into the blazing interior. Chief Rufus Fancher had ordered the men to move back from the swaying wall just seconds before it collapsed. Rescue work began immediately, as firefighters armed with shovels, axes, and poles endeavored to remove the pile of brick and stone that had buried firefighters. Firemen James H. Powell and Louis Coats of Steamer No. 1 were both pulled from the debris, injured but alive. Deeper in the debris were the burnt bodies of Capt. Joseph Condren, commanding officer of Steamer No. 2, and his colleagues, firemen William Reilly, Frederick W. Hale, and Frank Williams. (Courtesy of NHFD/TA.)

Hook and Ladder Company No. 1, the only aerial ladder in the city in 1899, demonstrates its water tower in this scene. During that year, two firefighters died while on duty. Walter P. Hovey expired suddenly on July 12 while performing his duty as night operator at headquarters, and hoseman Jeremiah F. Regan of Engine Company No. 8 was killed when he was thrown from the hose wagon while responding to an alarm on November 20.

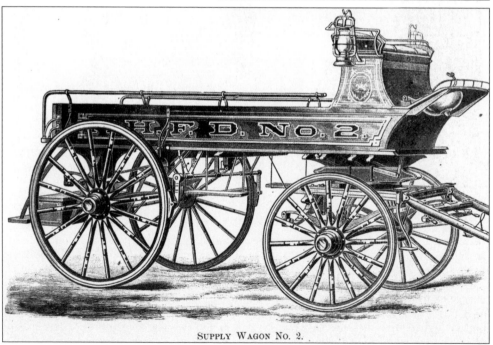

SUPPLY WAGON No. 2.

Every station had a supply wagon to help transport equipment and men to and from fires. The supply wagon was used to bring bales of hay and feed for the horses. The wagons were not large enough to handle the many tasks associated with running a station and eventually were redesigned for two horses in order to handle the heavy workload. This illustration dates from *c.* 1900. (Courtesy of NHCHS.)

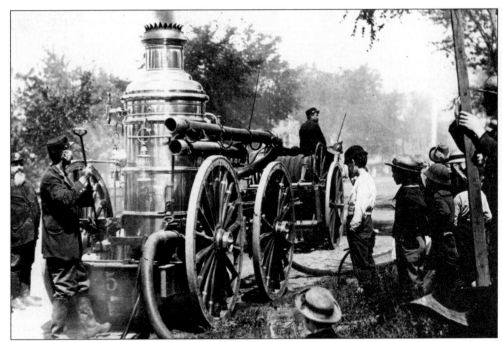

Blatchley Avenue, in the city's Fair Haven section, was always a good location for company training. Here, Steamer Company No. 5 is fed coal to keep the fire going and produce enough steam to pump the hose lines. The hose cart is in front of the steamer. The horses that pull the steamer and hose cart have been unhitched and led away from the action to ensure their safety. (Courtesy of NHCHS.)

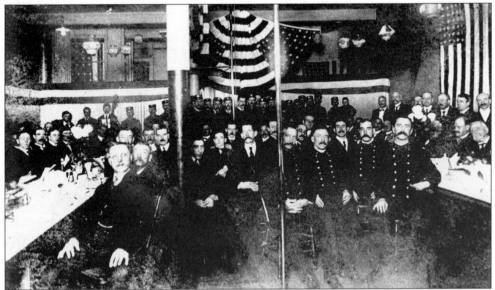

A patriotic banquet held in 1902 at the Artizan Street station, home of Hook and Ladder No. 1 and Steamer Engine No. 2, drew a large crowd of city officials, fire commissioners, and members of the department. Mayor John P. Studley had words of praise for Chief Rufus Fancher and his department. The apparatus floor was transformed into a hall for the occasion. (Courtesy of NHFD/TA.)

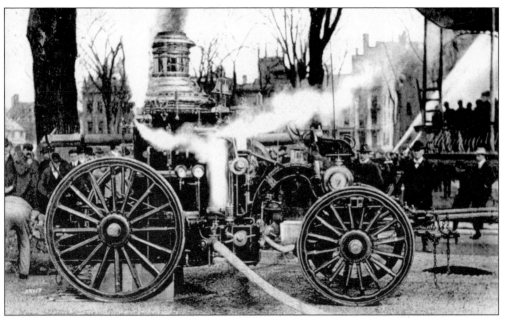

A large crowd gathered on the New Haven Green, near the old concert grandstand, to observe the pumping power of Engine Company No. 7, quartered at the Water Street station. The first-size Clapp & Jones steamer, painted black, was purchased in 1902. Testing of newly purchased or refurbished apparatus always drew a throng to watch the firefighters guide the powerful streams of water through the hose nozzle. (Courtesy of Roger Lambert.)

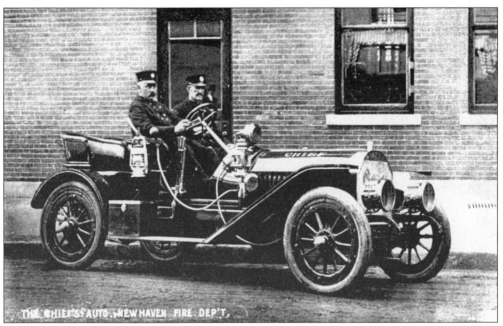

Fire Chief Rufus Fancher, sitting in the driver's seat, replaced his horse and buggy with the fire department's first motorized vehicle, a 1908 Continental runabout automobile. The following year, he stated, "It would be impossible to do half the work with horses that I now accomplish." (Courtesy of Roger Lambert.)

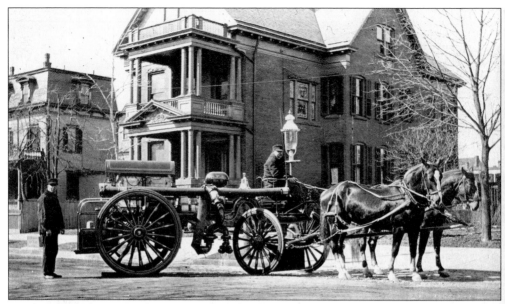

It is a little known fact that electrical giant Westinghouse—best known for its household appliances—at one time manufactured gasoline-powered fire engines. New Haven's 1909 Westinghouse, equipped with a two-horse hitch and preconnected soft suction for quick hydrant hookup, went into service at Engine Company No. 9. Chief Fancher said, "It would be a matter of economy to replace our steam fire engines with automobile pumping engines once they are developed."

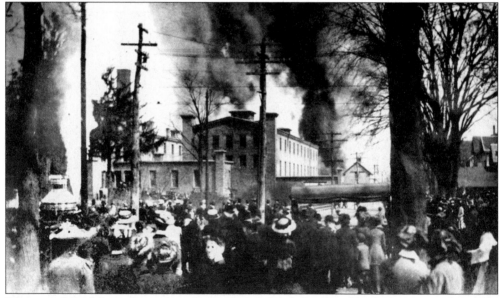

Six trapped firefighters burned to death as they battled a fire that broke out in the early-morning hours of April 13, 1910, at the chair shop at New Haven County Jail on Whalley Avenue. The victims were firefighters John Buckley, James Mortel, Thomas McGrath, James Cullen, Lt. William Dougherty, and Capt. Charles Chapman. The remains of three of the victims are interred in the burial grounds at the Firemen's Monument in Evergreen Cemetery. (Courtesy of New Haven Fire Training Academy.)

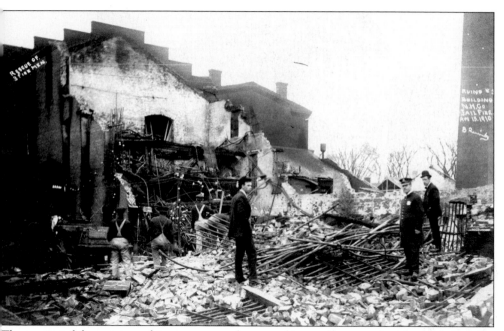

The tragic jail fire originated in a two-story frame packing and storage shed located along the County Street side of the chair factory. Inside the factory, the chairs were manufactured and dipped in varnish before they were slid through two chutes that connected the factory to the shed, where the chairs were wrapped and stored. Two hundred ninety prisoners were safely evacuated. Twelve firefighters were injured, some of them severely burned.

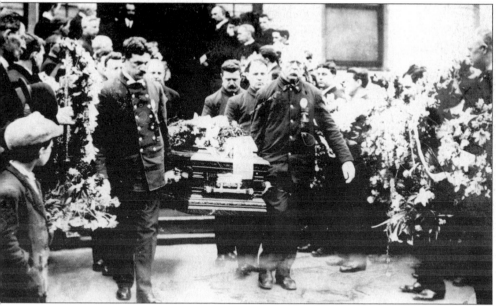

The coffin of hoseman James Cullen, a 35-year-old widower, is carried from the Chapel of St. Rose Church by mourning firefighters. On the day of the fire, as Cullen lay buried far beneath the fallen walls of the jail, his two sons, seven-year-old Harry and five-year-old Jimmy, waited at the door of the engine house on St. John Street for their father to return. This time, they grew impatient and wondered why their papa did not return.

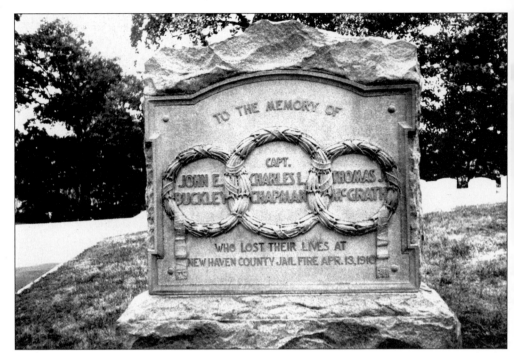

The tombstone at the Evergreen Cemetery marks the burial site for the remains of John Buckley, Capt. Charles Chapman, and Thomas McGrath. The New Haven Fireman's Benevolent Association maintains the historic burial plot, which is a final resting place for many firefighters. A memorial inscribed with the names of those who have died in the line of duty is part of a mural in the auditorium at the New Haven Fire Training Academy.

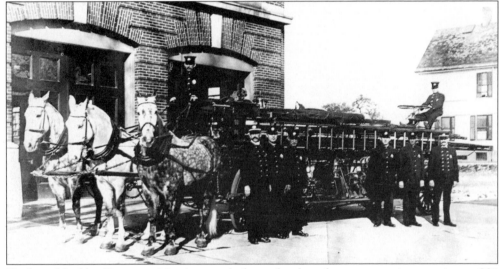

Hook and Ladder Company No. 4, a truck drawn by three horses, went into service at 384 Dixwell Avenue in June 1906. Built by the American La France Fire Engine Company, it was equipped with ladders, hooks, axes, picks, and an Eastman deluge set. In 1910, the men assigned to this company were Capt. John E. James, Lt. Louis P. Hurley, and hook-and-ladder men Michael S. Carroll, Edward H. Mayer, Brigham B. Payne, Richard M. Jones, John P. Ryan, and Frank W. Collett. (Courtesy of Joe Taylor.)

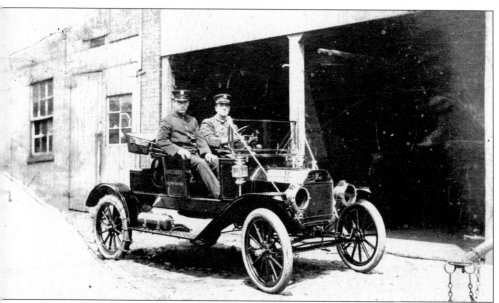

William B. Perkins (fire marshal and assistant chief) is shown at the steering wheel of his new 1911 runabout, which was purchased for $1,500. By this time, the roster of the department had risen to 171 permanent men, who were assigned to 13 engine companies and 4 hook-and-ladder companies. There were 72 horses on duty in the department. (Courtesy of New Haven Fire Training Academy.)

These 14 recruit firefighters just graduated from the Water Street Training Facility in 1911. Members of the group are James C. Shaw, Bernard F. Donahue, William F. Connelly, John H. Collins, Thomas F. McHugh, Martin H. McNamara, Charles R. Goldrich, George Porter, David E. Beecher, William J. O'Connell, John M. Lonergan, Patrick F. Sullivan, James McKenzie, and Dennis F. Slattery. Each was to earn $2.50 per day. (Courtesy of New Haven Fire Training Academy.)

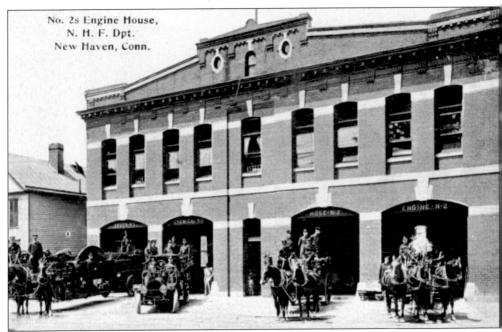

The Steamer No. 2 station, at the corner of Olive and St. John Streets, was the home of four fire units. Engine No. 2, a first-size La France steam fire engine, was purchased in 1905; the hose wagon was delivered in 1885; the motorized combination chemical engine and squad wagon went into service on June 21, 1911; and the American La France aerial truck of Hook and Ladder No. 1 was obtained in 1905. (Courtesy of Roger Lambert.)

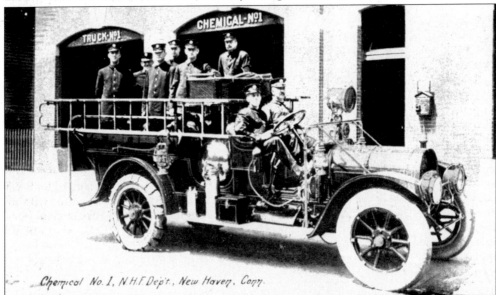

The motorized combination chemical engine and squad wagon greatly improved firefighters' ability to extinguish flammable liquid fires, and decreased the response time for transporting firefighters to the scene. The changeover to motorized equipment was slowly taking place between 1908 and 1921. The horse-drawn equipment eventually faded into history. (Courtesy of Joe Taylor.)

The unsung heroes of the fire department were the horses who pulled the steamers, hose wagons, ladder trucks, and chief's and fire marshal's buggies to fires. Sadly, many of the horses suffered injuries and died in the line of duty. On July 23, 1911, at 1:38 a.m., Steamer No. 6 was responding to a fire alarm when it was struck by a freight train as it crossed over the railroad tracks on Division Street. The two horses pulling the steamer died in the accident. The city of New Haven received a check for $600 from the New York, New Haven and Hartford Railroad Company for the loss of the two horses. There were no barriers or warning bells at the railroad crossing and no quick way to halt the galloping steeds. As units returned to their stations from fires, the horses were always treated to buckets of oats as reward for their hard work. Little by little, as motorized fire apparatus was introduced, the horses were sold and placed in different lines of work. Some went on to pull wagons and carts for delivering milk and coal. (Courtesy of New Haven Fire Training Academy.)

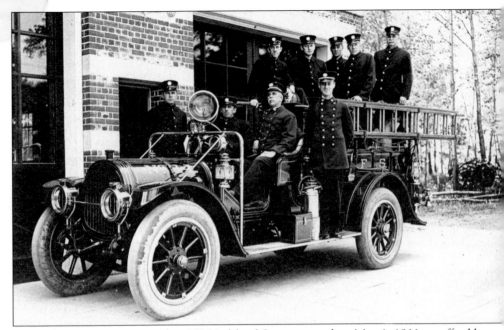

A new fire station constructed at 150 Highland Street opened on May 1, 1911, to afford better fire protection to the Prospect Hill District. The city's first piece of automobile apparatus—a Pope-Hartford combination chemical engine and hose wagon—was placed in service here. Company members pictured aboard the wagon are, from left to right, as follows: (front) driver Hugh A. Crowe, Capt. Charles H. O'Neill, and Lt. Francis H. Miller; (rear) Edward M. Roche, Thomas H. Keyes, John F. Lynch, David E. Beecher, and Michael H. Rourke. The firefighter standing near the door is unidentified.

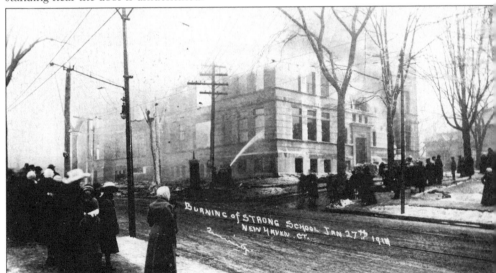

An early-morning fire at the Strong School on Grand Avenue in Fair Haven destroyed the four-story, yellow-brick structure. The devastating fire consumed all the schoolbooks, furnishings, and paintings and wiped out the library. Smoke from the blaze was so dense that Steamer Company No. 5 (the first company to arrive at the January 27, 1914, fire) had to slow the horses to a walk as they approached the burning school.

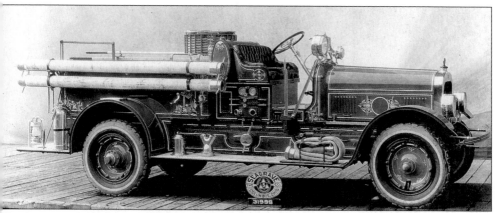

The Seagrave Company of Columbus, Ohio, added a shaft-drive pumper to its line. The new series of pumping engines had been handsomely restyled, with a gracefully rounded hood, radiator, and cast cowl. The New Haven Fire Department adopted the Seagrave apparatus for its innovative design, and eventually all the pumping engines and hook-and-ladder trucks came from the Seagrave factory. The 1922 Demonstrator pumping engine is shown here with its solid disc wheels.

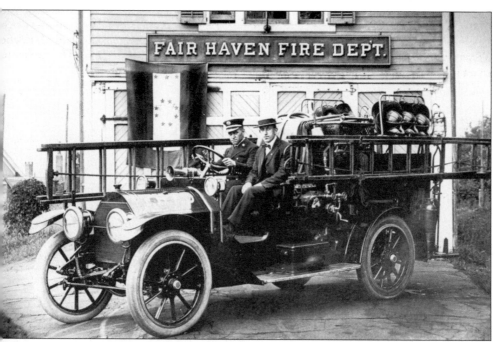

Historic Fair Haven Heights had its own fire department to cover the eastern side of the Quinnipiac River. In 1916, members of the company had dress uniforms, were well organized with a chain of command, and responded efficiently to the needs of the community. The small station was located next door to St. James Episcopal Church on East Grand Avenue. At times, when things got out of hand, units from New Haven would cross over the bridge to assist the Fair Haven firefighters. (Courtesy of NHCHS.)

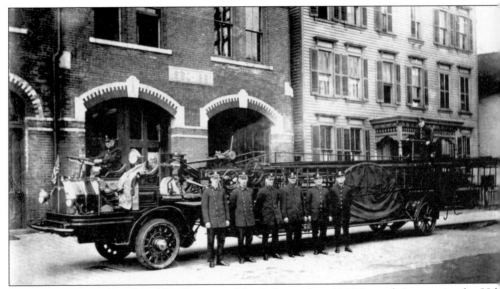

Firefighters of Hook and Ladder Company No. 2, located at 444 Howard Avenue in the Hill section, are shown *c.* 1918 with their Seagrave 75-foot aerial front-drive truck, which was commissioned on April 12, 1916. From left to right are the following: (on truck) driver James Mangan and tillerman John Curran; (standing) Capt. Francis Spaine, Lt. Matthew Bohan, Sylvester McNerney, Francis Nicolari, Samuel Isaacs, and Robert Grey.

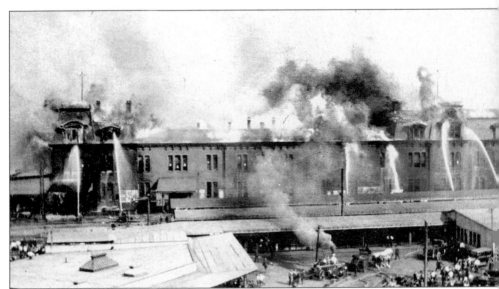

A fire at New Haven Railroad Depot on May 10, 1918, swept through the building, located at the foot of Meadow Street. Hoseman James F. Weldon, 43, was injured by falling debris from the ruins of the blaze and suffered a skull fracture and internal injuries. He died the following day at New Haven Hospital. Several other firefighters sustained burns and disabling injuries.

# *Three*

# THE ROARING TWENTIES

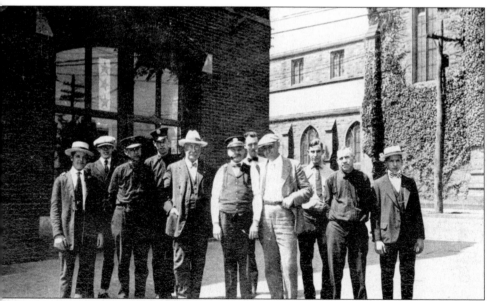

There was always time to take a photograph on a Sunday afternoon. In this c. 1920 snapshot, Chief Rufus Fancher (fifth from left) is joined by members of Engine Company No. 3 and friends in front of the station facing Park Street. In the background is the Christ Church, at 48 Broadway. Fancher was in his 22nd year as chief of the department. William C. Celentano (the young man at the extreme right) became mayor of the city of New Haven in 1945.

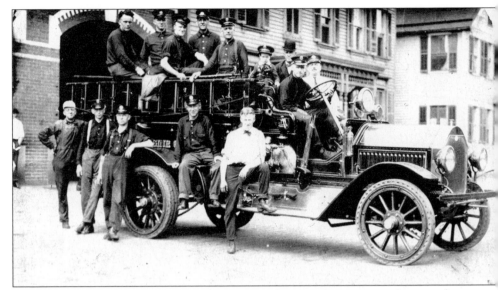

Engine No. 1, one of the department's first motorized pieces of apparatus, is shown in the summer of 1920 outside the Howard Avenue station. Members of the company are, from left to right, as follows: (front row) Frank Blatchley, Ed Monahan, James Mangan, Henry Weber, and Capt. Francis Spaine; (back row) John Roach, Jack Lillis, Sylvester McNerney, John Horn, Terrence Reynolds, Jim Hope and son (company mascot for the day), Paul Heinz (at the steering wheel), and Capt. Russell Ellis. Heinz went on to become chief of the New Haven Fire Department.

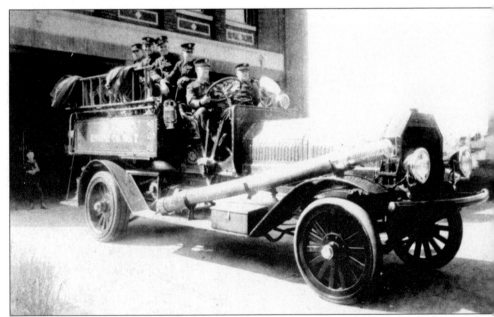

Members of Engine Company No. 7, aboard a 1912 Seagrave model, leave the Water Street station to survey their district. This engine, then state of the art, was able to efficiently supply four hose lines at fires. Pictured from left to right are John Roach, Raleigh Jones, Jack LeFebre, Michael Foley, driver William Merrick, and Capt. Louis S. Haggerty, who had been promoted to the rank on April 23, 1920, about the time the photograph was taken.

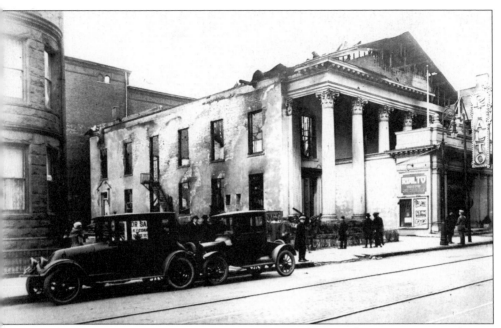

The most disastrous fire in downtown New Haven occurred on Sunday evening, November 27, 1921, when the old Rialto Theatre on College Street was razed by a three-alarm blaze, which claimed 9 lives, resulted in more than 75 civilian casualties, and injured 8 firefighters. In full view of crowds, two patrons made their way to fire escapes, only to burn to death. The overcrowded theater had been showing the silent movie *The Sheik*. (Courtesy of NHCHS.)

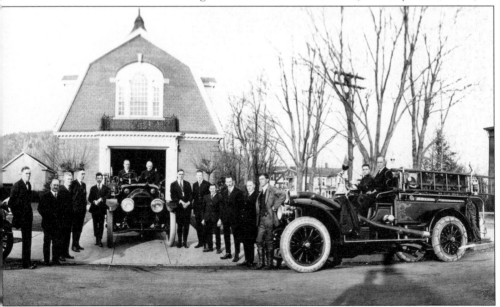

At one time a separate district, the Westville section became part of the city of New Haven on July 15, 1921. The Westville Fire Department headquarters, located on the corner of Fountain and Harrison Street, was reportedly the former site of Westville Village town hall. There was a safe in the basement and a small brick room that served as a jail cell. The two assigned apparatus became known as Engine Company No. 15 and Hook and Ladder Company No. 5.

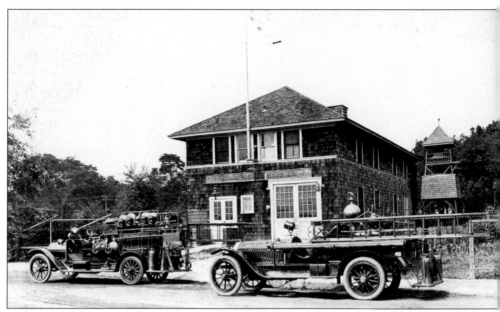

Morris Cove Hose Company, on Lighthouse Road, was an all-volunteer department until May 1923, when the 33rd Ward electors voted to annex the "Cove" territory to the city of New Haven. The company's two fire apparatus had served the community well under volunteer Chief Frank A. Murray, whose enthusiasm in firefighting made him a valuable member of the Cove Volunteers. The old wooden fire station was razed and replaced with a modern station and Engine Company No. 16.

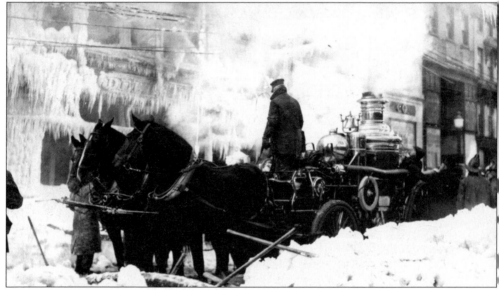

A winter wonderland of ice remains in the aftermath of a major blaze that destroyed the Mendell Freedman Building on Chapel Street in downtown New Haven on January 24, 1921. Frigid, subzero temperatures hampered firefighters' efforts to bring the fire under control. Steamer Company No. 4, one of the department's last horse-drawn apparatus, returned to the scene with a fresh crew of horses and men to continue wetting down and overhauling the smoldering ruins.

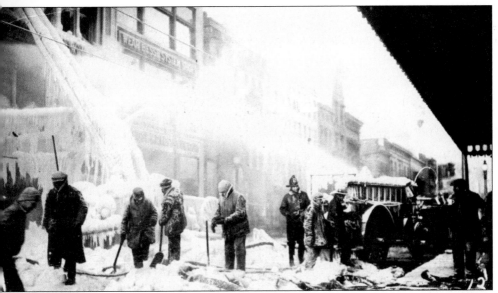

The morning after the devastating Mendel Freedman Building fire at 770 Chapel Street, across from the Shartenberg's Department Store, a mass of thick ice covered fire equipment and hose lines. The aerial ladder to the second floor is shown completely enshrouded in ice. The street was shut down the entire day while firefighters labored to free up the frozen equipment. Damage from the fire totaled $314,000.

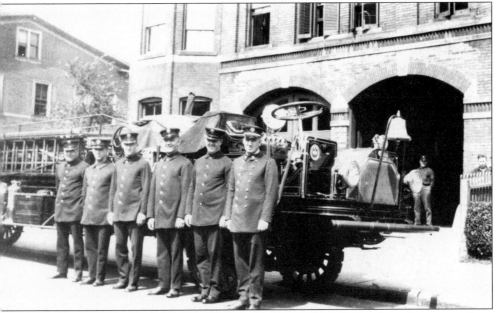

Hook and Ladder Company No. 6, a 75-foot Seagrave aerial truck, stands ready to go with its assigned members in front of the Edwards Street station in 1925. From left to right are John Nolan, Oliver Ryan, William Welch, Mark Marren, William McCullom, and Lt. Thomas J. Collins. In the year this photograph was taken, fire loss in the city totaled $685,780.26. Two firefighters died in the line of duty. Firefighters responded to 1,369 fires and alarms.

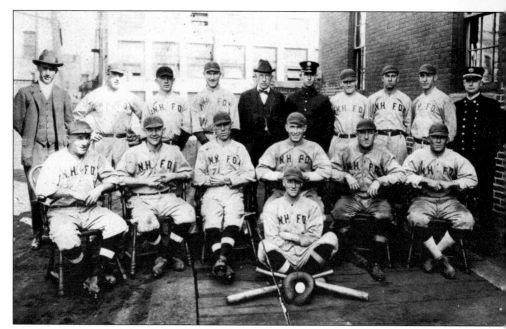

The fire department's baseball team for the 1927–1928 seasons traveled around the state and compiled a winning record while playing against rival fire department teams. Members of that squad pictured here are, from left to right, as follows: (at front) Sylvester McNerney; (first row) R. B. Webber, George Blackwell, Harry Ellis, J. O'Connor, James Leach, Martin Donahue; (second row) Capt. F. Riley (manager), Joseph Welch, Henry Otto, David Leach, Chief Rufus Fancher, John Lynch, William Schatzman, James Purcell, William Perkins, and Joseph Comiskey. This photograph was taken at the Howard Avenue station.

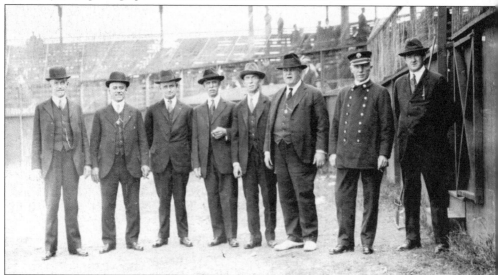

All dressed up to watch the New Haven Fire Department baseball team take on another opponent at Lighthouse Point Park Stadium in the summer of 1928 are, from left to right, Captain James, Deputy Fire Marshal Terrance F. Reynolds, J. Sweeny, Capt. Charles O'Neill, Battalion Chief Joseph E. Kelly, Captain Davison, Fire Marshal Martin Fleming, and J. Cronogue. The team had a large following of fans.

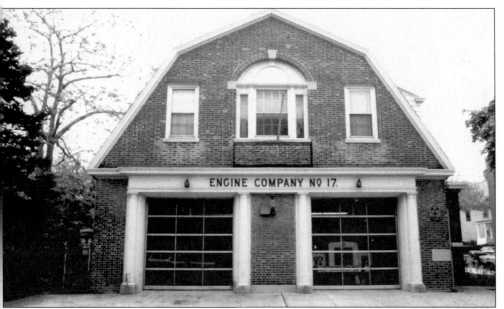

The Engine Company No. 17 station was located at Grand Avenue and Lenox Street, in the Fair Haven Heights neighborhood, to provide fire protection to all the territory east of the Quinnipiac River. Commissioned on January 3, 1928, the original firefighters assigned there were Capt. James Shaw, William Merrick, John Porter, William Friend, W. J. Foley, William R. Denison, J. J. Danz, William Chamberlain, Capt. Thomas Delaney, William Leeney, James P. Leach, M. Stackpole, J. J. Coffey, George Blackwell, T. Maloney, and John A. Calls.

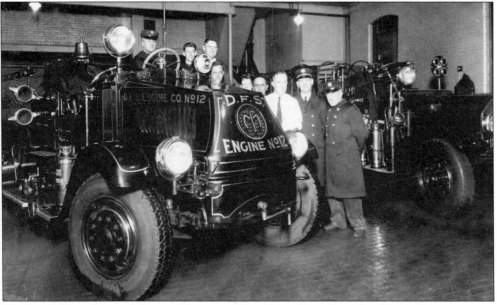

The big red machine of Engine Company No. 12 stands tall in the Crown Street station, surrounded by members of the department. Notice the hand crank at the front of the motor. Identified in the c. 1930 photograph are commanding officer Capt. Thomas L. Delaney (in the white shirt), who was assigned to the station in 1929, and Lt. William J. Langan (to the right of the captain). Sadly, both men died in the line of duty several years later.

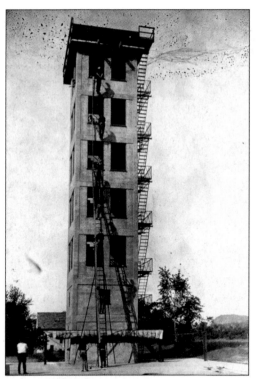

Here the drill tower at the rear of Dixwell Fire Station is the training site for the class of September 1931. Richard M. Greene (in the white shirt), assistant chief and drillmaster, observes the firefighters in their ladder skills as they practice on the scaling ladders. Members of the class shown in the photograph are Raymond Rogan, Andrew Flannagan, Frederick Kaiser, Victor Jackson, Michael Esposito, Edward Eagan, Russ Bartholomew (Prospect Beach Fire Department), Joseph Sheehan, Howard Paine, Lawrence Griffin (Annex Fire Department), and Walter Lloyd (Annex Fire Department).

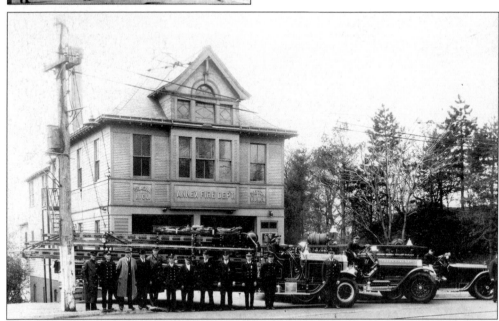

The Annex Fire Department (AFD) was organized on May 6, 1895, to cover the territory of New Haven's 31st Ward. The Beacon Hose Company and Dayton Hook and Ladder Company responded from this station, which was located on Forbes Avenue. The AFD was legally dissolved by the state of Connecticut on August 20, 1961. The above photograph was taken in 1931, when the Fairmont Association was the governing body of the Annex. (Courtesy of Charles Mascola.)

An early-evening fire at 825–827 Chapel Street on November 14, 1934, raced through the structure and destroyed the interior of Judd's Book Store and Reglino Shoe Company. For a period of time, flames threatened an adjacent building that housed the Globe Theatre. It took firefighters three hours to contain the three-alarm blaze that began in the cellar and traveled through the walls of the three-story structure.

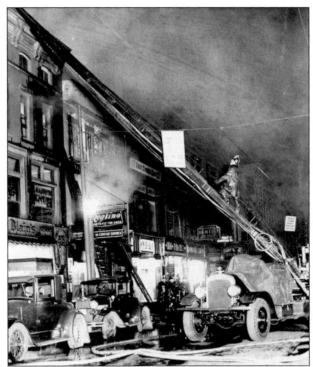

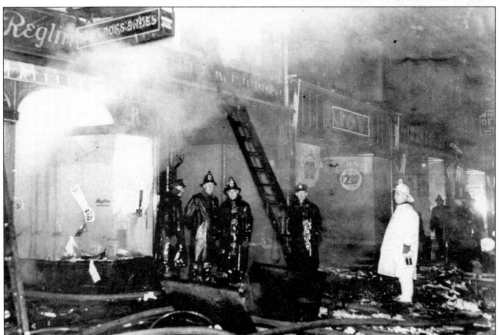

Chief Lawrence E. Reif (in white turnout gear) looks over the ruins of the November 1934 fire that imperiled a portion of the city's center. Only the efficient handling of the three-alarm blaze by the fire department and its 18 charged hose lines prevented the spread of flames beyond the area of origin. More than 20,000 people flocked to the scene after hearing radio reports that the main section of the city was in danger of destruction.

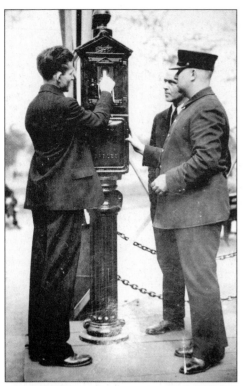

A new Gamewell alarm pedestal box is demonstrated on the New Haven Green, at Church and Chapel Streets, in 1935. The Fire Alarm Telegraph Division was headed up by John J. Roach, superintendent of fire alarms. During that year, 237 street boxes were painted—the upper portions were red (with aluminum tops and small doors) for greater visibility, and the lower sections of the pedestals were black. (Courtesy of NHCHS.)

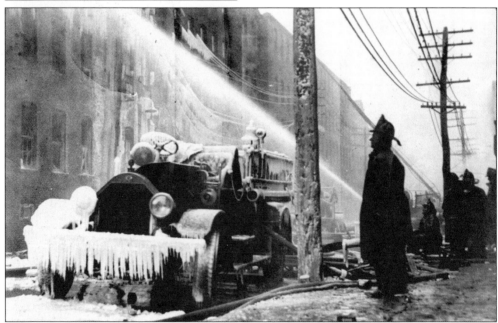

The five-story Candee Rubber Company plant, which housed 16 different concerns, went to a general-alarm fire on November 27, 1936. A wide area of the city's industrial sector was threatened when a major part of the East Street building was enveloped in flames. Eleven workers were led out of the building by firefighters. Seven firefighters were admitted to the hospital for injuries while 20 others suffered frostbite.

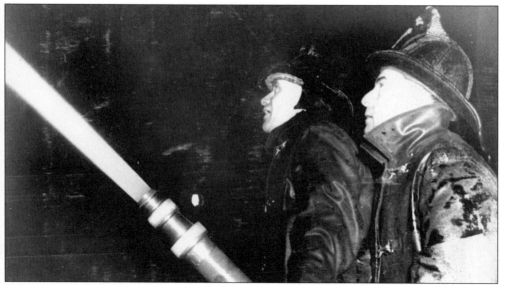

A solid stream of water, one of many supplied by 16 pumping engines, is poured through the windows of the upper floors of the Candee Rubber structure in November 1936. It took 2,500 gallons of gasoline to keep the fire engines running through the night. One fire apparatus was damaged when it was hit by pieces of the falling building. Freezing temperatures created icy conditions that hindered the efforts of firefighters.

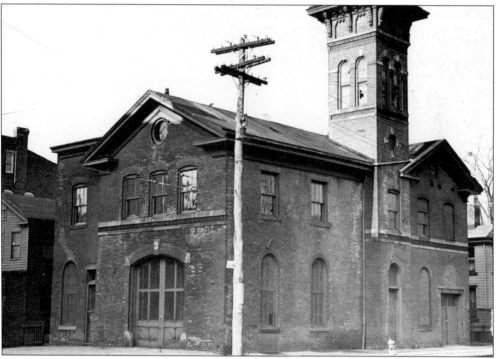

The Depression years took their toll on city government and the fire department budget, forcing the closure and deactivation of Engine Company No. 3 at its Park and Elm Street station. The vacant firehouse fell into disrepair, was boarded up, and became an eyesore in the Broadway–Yale University community.

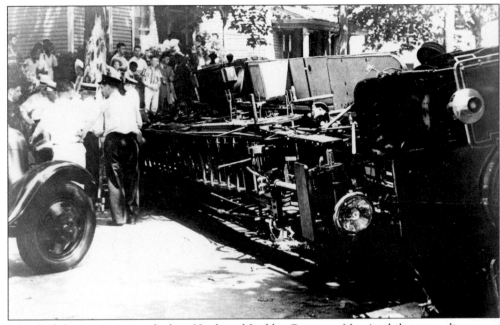

Four firefighters were injured when Hook and Ladder Company No. 4, while responding to an alarm, went out of control and smashed into a tree on July 17, 1937. The accident occurred on Orchard Street between Dickerman and Goffe Streets when the rear end of the truck slewed to the right and forced the front end out of control. Thrown from the apparatus were acting Capt. James McHugh, William Collins, Robert O'Brien, and Richard Jones, who suffered a broken leg.

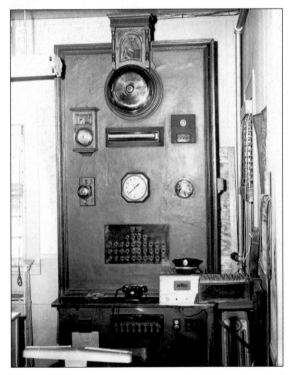

In 1942, all fire station watch booths were modified and rewired by the Repair and Fire Alarm Telegraph Divisions to provide a more efficient alarm system in all stations. Newly appointed Chief Paul P. Heinz wasted no time in his plan to modernize the department, which had fallen on financial hard times during the Depression.

# *Four*
# THE WORLD WAR II ERA

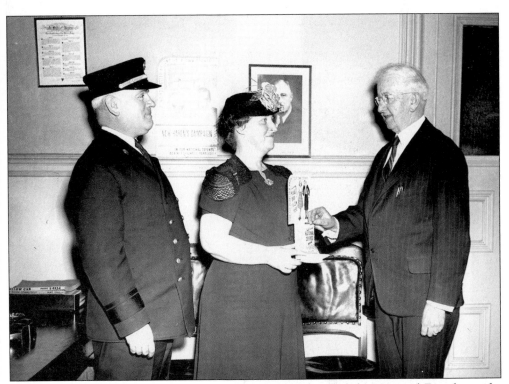

In 1938, Pres. Franklin D. Roosevelt, a victim of polio, founded the National Foundation for Infantile Paralysis to search for a cure for this often deadly disease. The March of Dimes campaign was initiated shortly thereafter to raise funds for the foundation. In 1941, Fire Chief Paul Heinz (left), chairman of the local March of Dimes, attended the New Haven campaign kickoff ceremony in city hall, where Mayor John W. Murphy (right) contributed to the canister held by the unidentified volunteer.

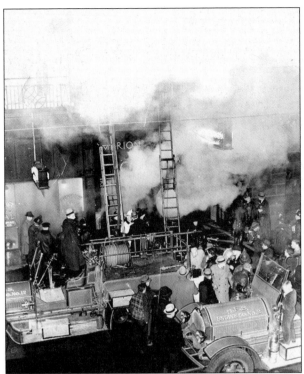

Firefighters fought for three hours before they were able to bring under control a fire at 129 Temple Street on February 14, 1941. The blaze gutted the Marion Berryman Beauty Salon and also caused extensive damage to Stone College on the building's second floor and to neighboring businesses Benedict & Company, a fuel and coal dealer, and Albrams Women's Wear. Fifteen firefighters were overcome by noxious smoke as they battled the multiple-alarm fire.

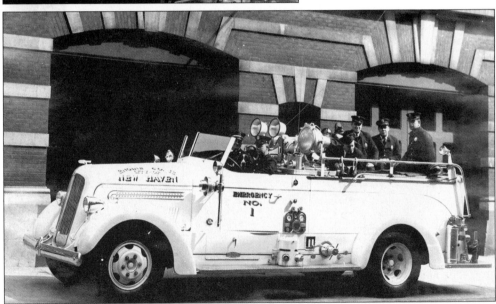

The New Haven Fire Department's first emergency unit was established when Engine Company No. 12 was converted to serve as Emergency Unit No. 1 in 1941. Headquartered at the Crown Street station, the unit was equipped with two-way radio, a public address system, and special appliances for use in rescue work. It was the first company to be equipped with gas masks for entering confined toxic areas. The unit was also outfitted with a new triple-service resuscitator to treat victims of electrocution, gas inhalation, and drowning, and those who had stopped breathing.

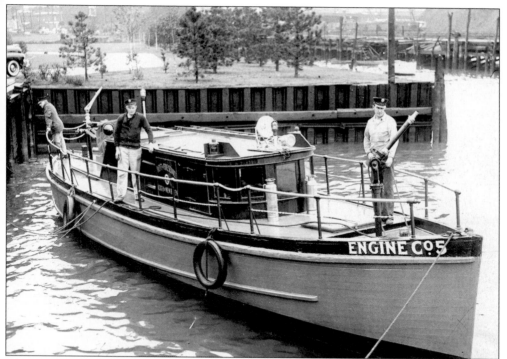

The city's first fireboat, dubbed the *John W. Murphy*, went into service on October 8, 1941. The craft assigned as Engine No. 5 was a former police harbor patrol boat that had been reconditioned under the direction of Capt. Albert H. Abeles, supervisor of motor apparatus. Bow and stern deck guns capable of discharging 1,100 gallons of water per minute were installed on board. The boat was quartered at the East Street Disposal Plant dock.

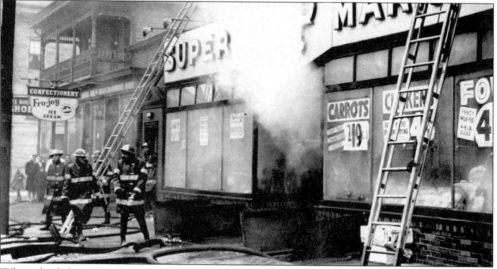

When firefighters arrived at the A&P supermarket in the early-morning hours of January 6, 1942, there was no time to do shopping. The men were engaged in battling a three-alarm blaze that had erupted in the basement at 112 Grand Avenue. Ten occupants of the second-floor living quarters were routed by the heavy smoke and quickly moved to safety. It took six hose lines to bring the fire under control, as the temperature hovered around 10 degrees.

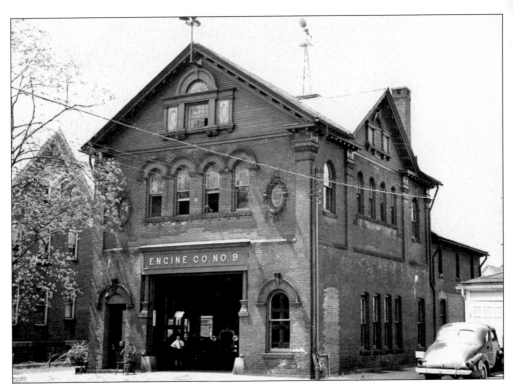

The fire station for Engine Company No. 9 was built in 1897 and featured a spiral staircase between floors that was designed to keep the horses from attempting to climb the stairs when they got loose and roamed the station. This photograph shows the station at 120 Ellsworth Avenue in 1942 with a civil-defense siren mounted on the roof. Firefighters maintained a large vegetable garden in the rear and shared their crops with neighbors.

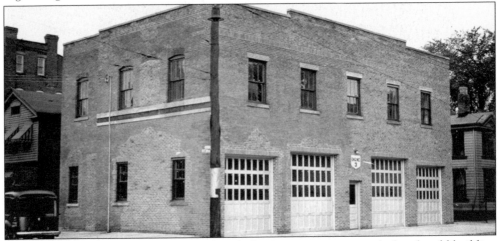

In 1942, Engine Company No. 3, at Park and Elm Streets, was reopened after the old building had been renovated. Around that time, Chief Paul P. Heinz was reorganizing fire company assignments to ensure that the many manufacturers that produced war materials in the city would have increased fire protection. Engine Company No. 9 was deactivated, and its staff was reassigned to the No. 3 station. Ladder Company No. 5 was moved to Ellsworth Avenue to cover the area with its Quad apparatus.

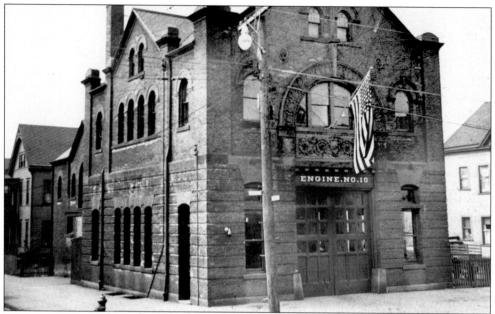

Shown in 1941, Engine Company No. 10 was built in 1916 at the corner of Lombard and Poplar Streets to replace the former station, constructed in 1897 at 222 Lombard Street. The Fair Haven area, a mixed community of residential, business, and industrial buildings, had grown rapidly and became a very active neighborhood. In the early years, the area's proximity to the Quinnipiac River and its booming clam-harvesting business had earned Fair Haven the nickname "Clam Town."

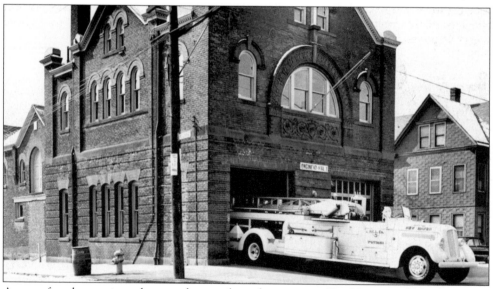

A year after the previous photograph was taken, the station in Fair Haven took on a new look when Hook and Ladder Company No. 3, a 1943 Seagrave 65-foot aerial ladder, was assigned new quarters. The closing of the East Pearl Street station, where the truck previously had been assigned, resulted in the consolidation of the two companies that served the western part of Fair Haven. Remodeling of the station at Lombard and Poplar Streets was extensive to accommodate the additional equipment and manpower.

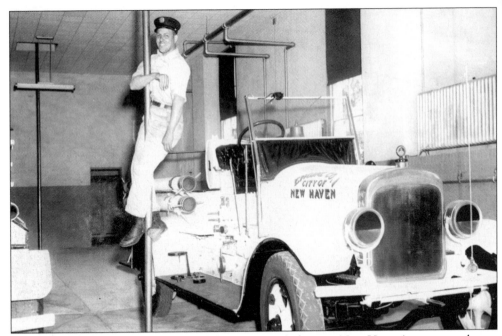

A ceremony on May 16, 1943, marked the opening of what was New Haven's newest and most modern fire station, 1st Battalion Headquarters, at the intersection of Howard Avenue and Putnam Street. The new station, housed in the converted old Washington School, replaced the two firehouses located at 720 Howard Avenue and at Howard Avenue and Lamberton Street. In this photograph, Fred Kaiser demonstrates sliding from the second floor on one of the four poles at the new headquarters.

Chief Paul P. Heinz (right) and Lt. John Quinn of Engine Company No. 12 examine a high-pressure fog nozzle in 1943. This firefighting equipment was used by the army in combating airplane fires. The progressive leadership style of Chief Heinz and his concerns about the war and security on the home front prompted changes in the department's firefighting tactics. Water fog was adopted as a new agent for extinguishing flammable liquid fires, and proper appliances were supplied to all stations.

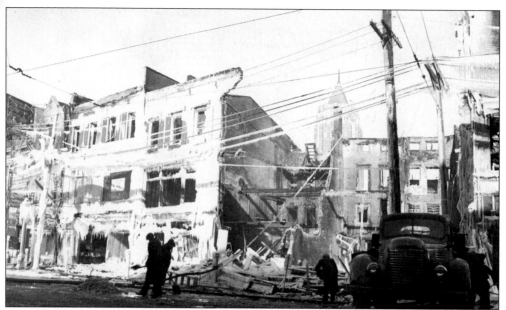

This is the scene in the aftermath of a five-alarm fire on December 23, 1943, that destroyed the business block that lined both Broadway and York Street. Thirteen business establishments and apartments were consumed by the blaze that went to a general alarm, fought under icy conditions. The fire was thought to have started in the College Toasty Restaurant before quickly spreading to Agnes McKay's Smoke Shop and Whitlock's Book Store.

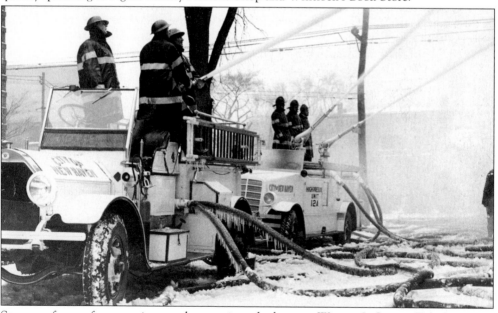

Streams of water from monitor nozzles pour into the burning Weiner & Cooper Tire Company, at 103 Broadway, on March 20, 1944. The fire went to four alarms as it spread to Lenox Hall on York Square. Newly issued helmets, designed to afford better head protection, are worn by three of the firefighters. New turnout coats helped firefighters to be more visible during World War II blackout conditions. The helmets worn by the three men on Unit 12A (the truck at the rear) are the old leather type.

# 1944 HONOR ROLL - WORLD WAR II

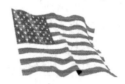

## MEMBERS OF THE NEW HAVEN FIRE DEPARTMENT
## SERVING IN THE ARMED FORCES

Paul V. Abt

Michael J. Bohan

Anthony Caprio

Harold M. Clifford

Ernest J. Collins

Thomas F. Conlon

John W. Connelly

Francis A. Considine

Nicholas M. Cucinelli

Harold L.Donahue

John F. Eagan

John J. Emons

William Ferrara

John F. Fitzpatrick

Robert J. Gallagher

Paul W. Heinz

Arthur R. Jordan

Henry E. Martens

John J. Masterson

Edward C. McKiernan

George S. McNerney

Walter F. Moore

Stephen Rakiec

Frank H. Reynolds

Joseph E. Ryan

John E. Smith

Joseph F. Sullivan

John W. Walsh

Robert J. Zacks

The ranks of the New Haven Fire Department were depleted during World War II, as 29 active members of the department were called to serve in the armed forces. One captain, on a leave of absence, was called to service with the State War Council. At the end of the war, with their military service behind them, they all returned to their fire service careers.

New Haven firemen on November 18, 1944, drew nationwide acclaim for methods they used to quell a blazing 10,000 gallons of gasoline. A 500-gallon-per-minute Rockwood fog nozzle was instrumental in extinguishing the raging fire, and during the three-alarm incident, nine fog-type nozzles were put into operation by Chief Paul P. Heinz. The inferno had started when a freight train crashed in the railroad "cut" near the Fair Street Bridge. As the train passed through the cut south of Chapel Street, its tank car buckled and bolted in the air, striking high-tension wires, snapping them loose, and igniting the escaping gasoline that sent flaming rivers of gasoline over the tracks. Ten fire engines were at the scene, surrounding the blaze on all sides to subdue the fierce flames that raged to a height of 100 feet. It took 40 minutes to bring the fire under control.

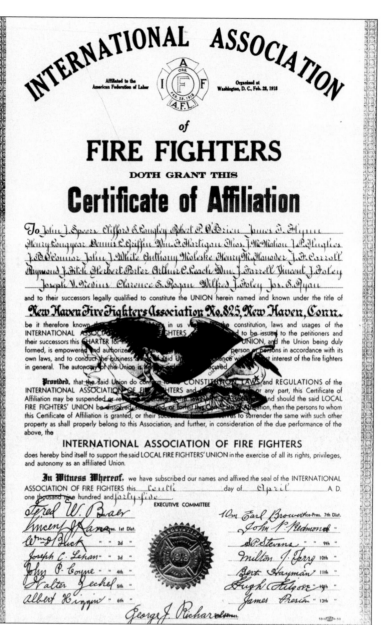

On April 10, 1945, the International Association of Firefighters issued a charter to New Haven Firefighters Association Local No. 825 of New Haven, Connecticut. The initial effort to unionize the firefighters was started in 1932 by firefighter William Mooney of Engine Company No. 4, who was president of the New Haven Firemen's Athletic Association. His inquiry to the International Association of Firefighters began a long, hard battle to organize and unite the rank-and-file members. During that era, it was taboo to talk union, and many of the advocates were called "rabble rousers." The 23 charter members of Local No. 825 were James Carroll, William Farrell, Raymond Fitch, James Flynn, Vincent Foley, Wilfred Foley, Dennis Griffin, Henry Hanover, William Hartigan, Joseph Hughes, Clifford Langley, Arthur Leach, Henry Longyear, Thomas McMahon, Anthony Moleske, Joseph Nevins, Robert O'Brien, Jeremiah O'Connor, Herbert Porter, Clarence Rogan, Joseph Ryan, John Speers, and John White.

*Five*

# FACTORY FIRES AND FIREFIGHTER DEATHS

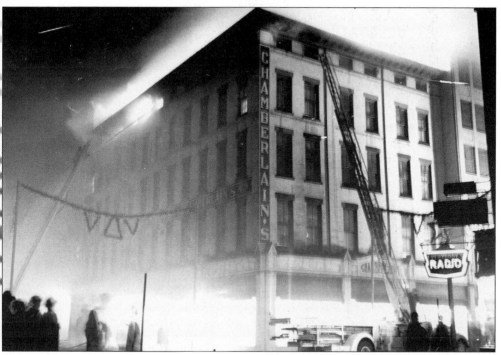

A general-alarm fire on Crown Street threatened to destroy the block on January 12, 1946. Shown above is Chamberlain's Furniture, where the fire has jumped from the fourth floor in the old Odd Fellows building to the fifth floor of Chamberlain's. It took several water towers and aggressive firefighting tactics at the site to keep the fire from ruining a stretch of downtown businesses.

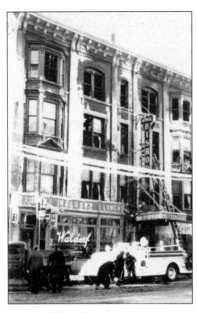

A five-alarm blaze swept through the third and fourth floors of the Hotel Bishop, at Chapel and High Streets, on January 19, 1945. A former army doctor died in the fire, which broke out shortly after midnight. Thirty-four others escaped as firefighters worked through freezing temperatures to quell the raging flames. In battling the inferno, the city's firefighting resources were terribly depleted until off-duty personnel reported to their stations to man the spare equipment.

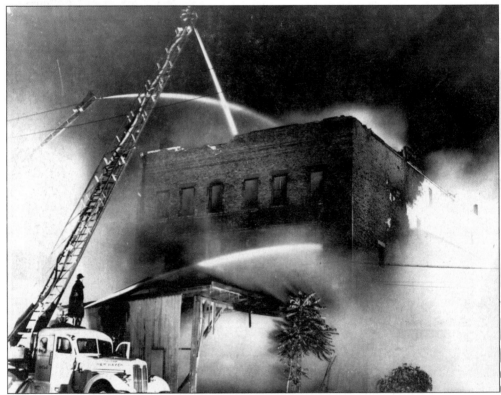

This fire raged uncontrolled for over three hours after it was discovered at 7:04 p.m. on June 22, 1946, at the five-story brick electrical equipment warehouse of the H. M. Tower Corporation and wholesale grocery stockrooms of Hodes Brothers, at 207 Water Street. The five-alarm fire had gained a quick start that prevented firefighters from entering the building with hose lines. Deck guns, tower lines, and deluge units were rushed into operation.

ELECTRIC SAW

When a distinguished person came to New Haven, the fire department was often called upon to provide assistance. On this occasion in September 1947, one of the greatest explorers of modern times, Adm. Richard E. Byrd (left), visited the city and spoke before a large crowd at Rice Field in the Cedar Hill section. Mayor William C. Celentano Sr. employed equipment from the New Haven Fire Department Sound and Light Unit as he introduced the highly decorated navy officer.

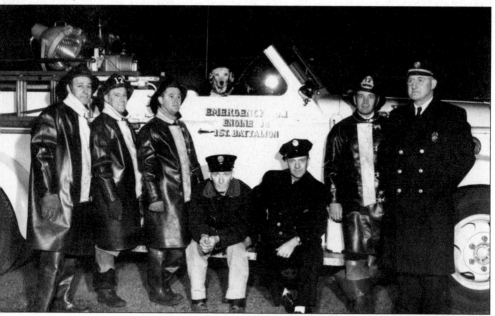

Firefighters assigned to Engine Company No. 12's Emergency No. 1 were assigned the tough jobs at major fires. The company recorded a glorious record of dedicated devotion to duty. In 1948, the men on one of the shifts included, from left to right, Charles Bogan; Michael Bohan; Paul Abt; James D. Connors (driver); John F. Eagan (deputy chief driver), Victor Jackson (captain); and Thomas J. Collins (deputy chief and drillmaster), former commanding officer of the company. Smoky, the Dalmatian, looks on from the truck.

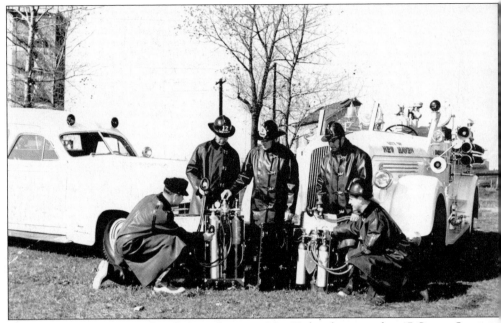

The E&J resuscitator carried on Engine Company No. 12, headquartered at 47 Crown Street in the downtown section, was just a part of the equipment used at medical emergency calls. Since 1941, the firefighters from Crown Street have responded on all emergency calls. On the left in this 1949 photograph is the surgical unit, a gift from James M. Bennett. The streamlined Cadillac was an ambulance-type vehicle used in responding to all multiple alarms and emergency calls.

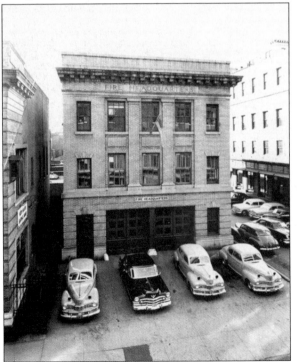

From 1862 until 1912, the administrative office of the Board of Fire Commissioners, chief, and fire marshal was housed at city hall on Church Street. A new headquarters building was completed in 1913 at 152 Court Street, pictured here in the 1950s. Chief Rufus Fancher stated, "The new headquarters will have one of the finest fire alarm systems, housed in a fireproof building, to be found in the United States." The Fire Alarm Telegraph Division occupied a portion of this structure.

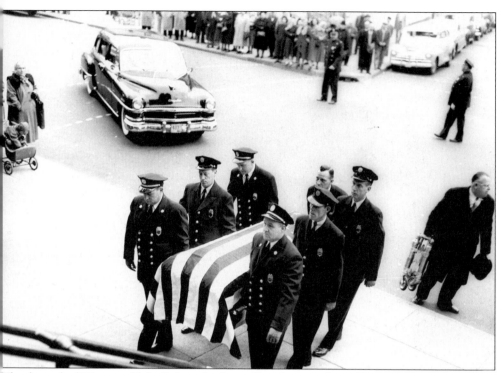

The funeral of 27-year-old firefighter Anthony Kuziel, a member of Engine Company No. 11, was held at St. Stanislaus Church on State Street. On November 23, 1952, Kuziel died in St. Raphael Hospital from injuries received at a four-alarm fire. He fell from the top of a ladder while near the roof of a fully involved four-story brick factory building at 41–43 Chestnut Street on November 12.

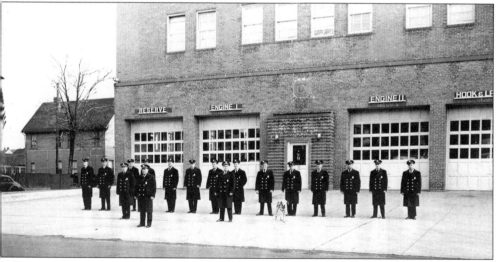

Officers and firefighters, along with the company mascot, stand at attention at the Howard Avenue station as they await the funeral cortege of their brother firefighter, Anthony Kuziel. A firefighter for just two years, Kuziel was a U.S. Navy veteran of World War II and is one of the youngest city firefighters to die in the line of duty. He left his wife, Helen, and two children, Elaine and Richard.

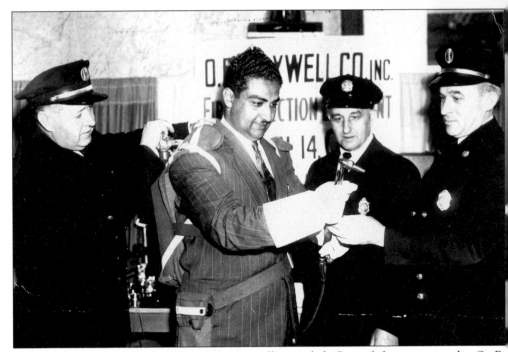

A fire equipment exhibit held in 1952 was well attended. One of the sponsors, the O. B. Maxwell Company—a supplier of equipment used by the department—featured a variety of tools at its booth. While checking out the exhibit, Capt. Thomas E. Kennedy (left) adjusts the backpack and acetylene tank on the unidentified person holding the cutting tool torch. Thomas Marino looks on while Lt. Francis McDonough assists with the controls.

The Fountain Street station, home of Engine Company No. 15, was completely remodeled in 1953 to accommodate the return of Hook and Ladder Company No. 5, which had been running out of the Ellsworth Avenue Station as a combination pump-truck since the 1940s. An increase in housing in the Westville community prompted the city to expand its fire response in the area. Engine Company No. 9, which had been deactivated in the 1940s, was placed back in service as well.

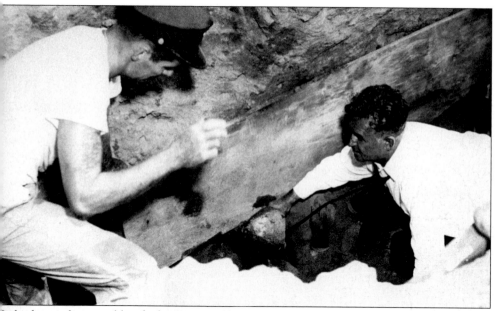

Only the sand-covered head of a 62-year-old laborer is visible as firefighters work feverishly to free him from a cave-in at a Westville construction ditch, where he was trapped for over an hour on September 5, 1953. Capt. Charles I. Bohan, commanding officer of Engine Company No. 15, administers oxygen while other firefighters shore up the sides of the ditch, which was in danger of collapsing again.

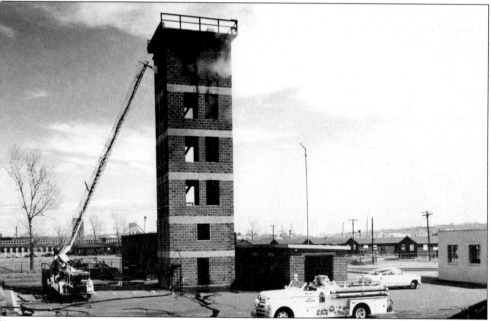

The training tower at the foot of Chestnut Street at Waterside Park was a harborfront landmark. Most of the training complex was built by fire department personnel who were detailed to the site. In the foreground are piles of lumber for the construction project that began in 1947 and continued through 1953. The entire site was demolished in 1956 to make way for the construction of the Connecticut Turnpike.

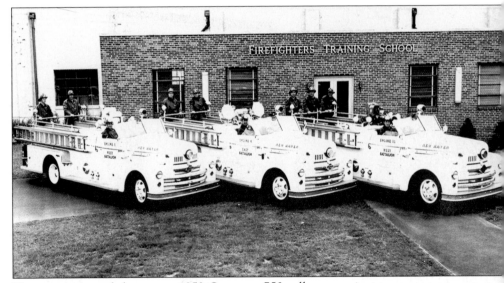

The acquisition of three new 1953 Seagrave 750-gallon-per-minute pumpers, at a cost of $15,000 each, modernized the department's fleet of apparatus and enabled the retirement of three ancient-vintage units. The new pumpers were assigned to Engine Company No. 3 at Park and Elm Street, Engine Company No. 4 on Olive Street, and Engine Company No. 12 on Crown Street. The new apparatus were manufactured in Columbus, Ohio.

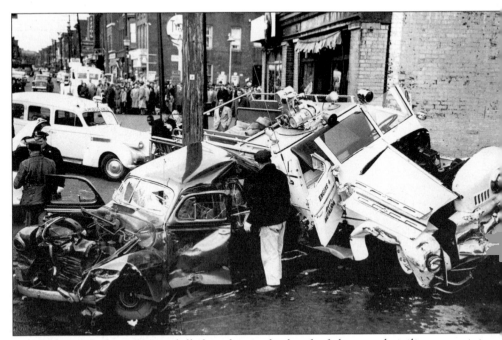

Capt. Edward Turbert, 53, was killed, and several other firefighters and civilians were injured when Engine Company No. 4 and a deputy chief's car collided at East Street and Grand Avenue on December 15, 1953. The vehicles were responding from two different directions to what turned out to be a minor fire at the National Folding Box Company in Fair Haven. Deputy Chief George F. Lynch was pulled from his vehicle in critical condition.

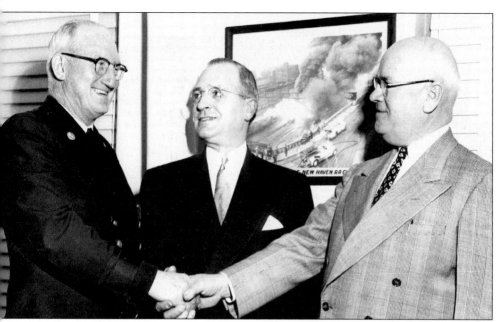

A handshake marks the changing of the guard on December 31, 1953, when Chief Paul P. Heinz (right) retired and Thomas J. Collins (left) was appointed to head the department by Mayor William C. Celentano Sr., who smiles at the new chief. Heinz served at the top of the department for 12 years, during which time the New Haven Fire Department earned recognition as one of the best-organized and best-trained fire services in the world.

Thomas J. Collins was a U.S. Army veteran of World War I, and upon his return to the United States in 1919, he joined the New Haven Fire Department. Collins owned the distinction of being the last man to drive horse-pulled equipment in responding to a fire when he was a member of Engine Company No. 4 in 1921. He served in every rank in the department (lieutenant, captain, battalion chief, deputy chief, and assistant chief) and headed up the Training Division as drillmaster as he climbed the promotional ladder to ultimately head the New Haven Fire Department.

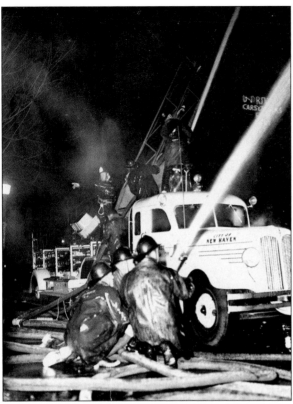

Steady streams of water reach the fourth level of the High Street Garage at a three-alarm fire on January 5, 1954. The blaze destroyed four cars and caused serious structural damage to the garage's fourth floor. Icy, freezing conditions hampered the efforts of firefighters on the scene shortly after 9:00 in the evening. While he was directing operations in front of the building, Deputy Chief Otto Lammlin narrowly missed being crushed by a 400-pound cornice that toppled from the fourth floor.

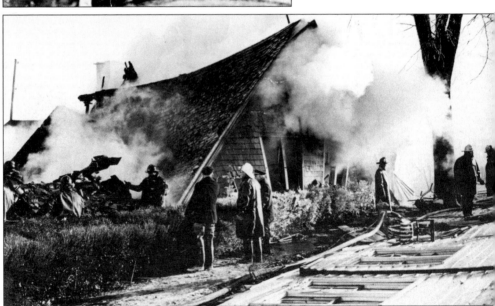

A three-family house at 513 Sherman Parkway was destroyed by an explosion that killed four occupants on February 1, 1954. The blast shook hundreds of homes and broke windows in the Beaver Pond Park area. Leaking gas from a broken underground main in the street was the cause of the detonation. Four occupants were rescued from the rubble by alert citizens. The entire building was at ground level when firefighters arrived.

Firefighters from Engine Company No. 6 take time out to warm up with a little coffee after getting the fire under control at the explosion site on Sherman Parkway in February 1954. The two alarms summoned scores of firefighters to the scene. Fearing a second explosion, emergency workers evacuated more than 00 people who lived in the immediate area. Twenty minutes after the first blast, there was an explosion that rocked a one-family home, but the residents had already been evacuated.

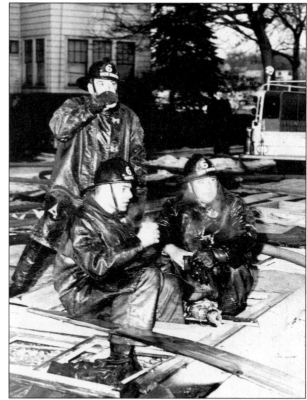

The Seamless Rubber Company blaze, on February 3, 1954, gave firefighters a tough battle. The smoke from the three-alarm fire at the Hallock Avenue plant was so thick that the building was obscured from the view of spectators at times. In this scene, Sam Levchuk, George Grandenetti, and Lt. Clifford Lynch have just removed their masks after venturing into the subbasement for the fourth time.

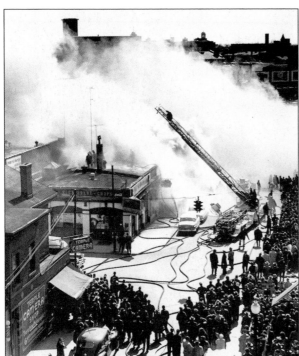

On the afternoon of March 22, 1954, a three-alarm blaze heavily damaged a block-long row of stores on Temple Street, between George and Commerce Streets. According to Fire Marshal Eugene Mulligan, the flames started in the Henry G. Breunig Company tire and radio firm at 47 Temple Street. Hose lines were snaked through a large crowd that gathered at the scene.

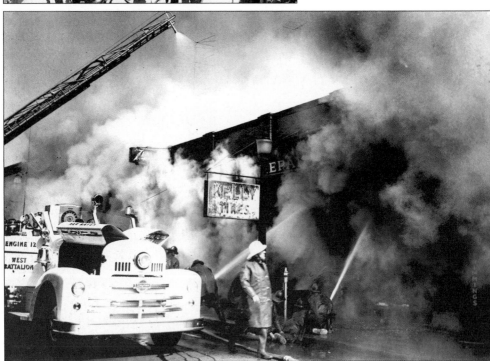

The Breunig store, where the big fire got its start, was the scene of an almost identical three-alarm fire on Good Friday, April 7, 1939. In both cases, the flames originated in the cellar in the heating system, and in both instances, damage was exceptionally heavy. Many of the firefighters, some shown here at the Kelly Tire section, took part extinguishing in both fires.

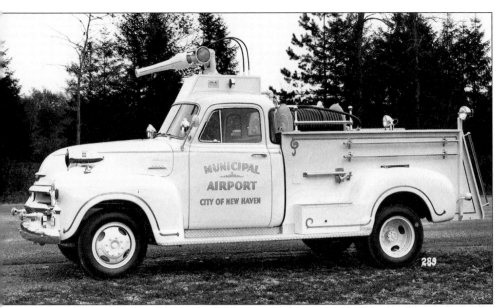

It was called "Little Mo," but its fire-suppression power was mighty. Those were the words used to describe the airport response unit, a 1954 Chevrolet, provided by the Young Fire Equipment Corporation in Buffalo, New York. Assigned to Lighthouse Station in the Morris Cove community, the airport unit responded with Engine Company No. 16 to all alarms for Tweed New Haven Airport. In later years, "Little Mo" was converted to a brush fire unit.

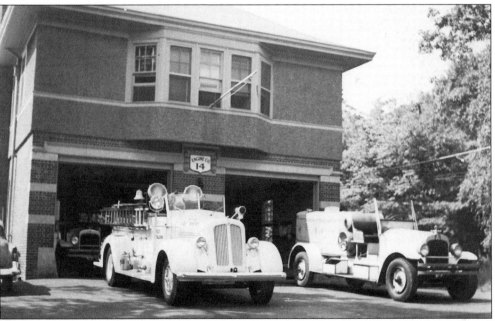

Engine Company No. 14, with its vantage point at the top of the hill at 150 Highland Street, delivers quick response to the Newhallville and Dixwell communities on one side, and to the East Rock neighborhood at the downside of the hill. Shown in this 1950s photograph, to the right, is the Schramm mobile electric generator unit that was used to power electric drills and saws and to provide necessary current to light up 10 large, portable 250-watt floodlights.

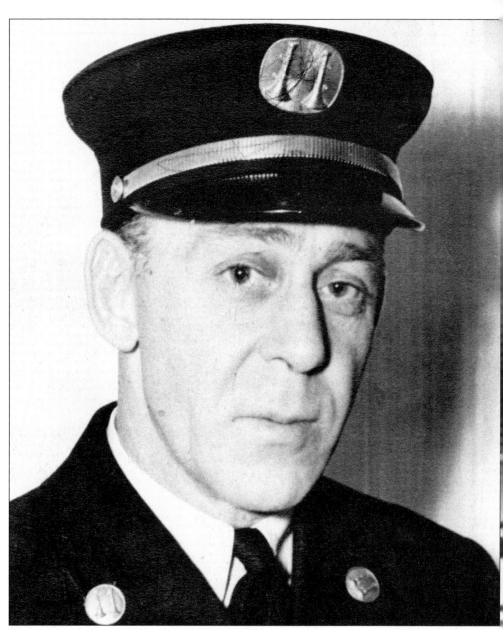

The death of Assistant Chief George F. Lynch on June 1, 1954, caused quite a stir in the department as he had been slowly moving along the road to recovery since being injured in a crash of fire equipment nearly six months before. Lynch suffered fractures of the collarbone and ribs, and punctures of the lungs and chest in an accident that took the life of Capt. Edward Turbert. Lynch was answering a box alarm on December 15, 1953, when his official car, driven by Ernest Collins, collided with the apparatus of Engine Company No. 4 at Grand Avenue and East Street. The two fire units then slammed into three private automobiles. Lynch, his driver, and seven other people were injured. A veteran of 35 years in the department, Lynch was a deputy chief at the time of the fatal smashup and was promoted to second in command of the New Haven Fire Department by the Board of Fire Commissioners six days after the accident. This photograph of Lynch dates from the 1930s.

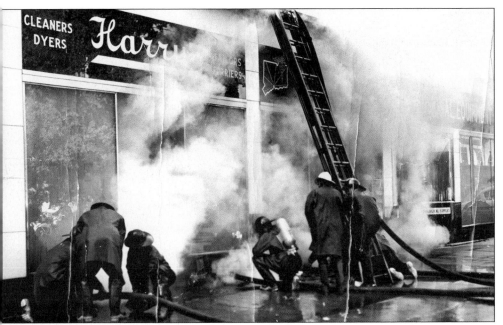

Five firefighters were injured at a three-alarm fire in the cellar beneath the Professional Equipment Company and Harry's Cleaners, at 36–40 Howe Street, on September 2, 1954. Firefighters were confronted by thick, stubborn smoke when they arrived on the scene shortly after 3:30 pm. Lack of ventilation made it difficult for firefighters to reach the seat of the blaze in the confined cellar area, which was filled with hospital supplies, wheelchairs, mattresses, beds, bandages, and tanks of oxygen.

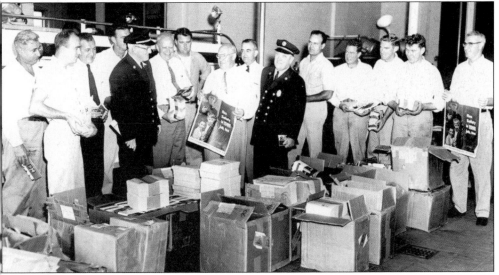

The theme of Fire Prevention Week 1954—"Fire safety is your job, too"—is expressed on the hundreds of posters that were displayed around the city. Here, members of the Chamber of Commerce deliver the poster materials to the firefighters. From left to right are Charles Mauro, William Carey, Thomas McNamara, Joseph Healy, Chief Thomas Collins, unidentified, Thomas Sullivan, chamber representative Sam Henry, unidentified, Fire Marshal Eugene Mulligan, Alfred Jessey, James Halley, Robert Gilhuly, Thomas Darney, and Edward McKiernan.

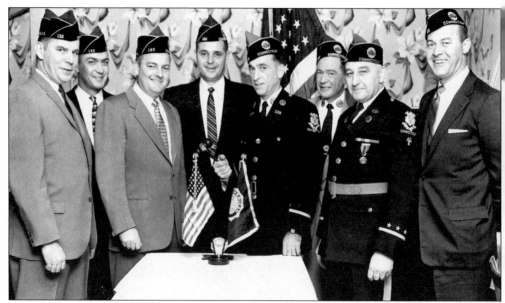

Chartered on April 14, 1934, the New Haven Fire Department American Legion Post No. 132 holds its installation ceremony for officers in 1954. From left to right are Thomas Darney, Clifford Lynch, Robert Lynch, Alan J. Turner, Leo Reilly, James Hally, Thomas Marino, and Henry Woyjtna. The Legion post membership comprises military veterans who served the United States during the wartime eras. Reilly, the post commander, passes the gavel to incoming commander Lynch.

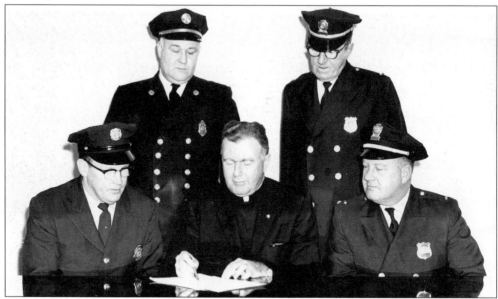

On February 1, 1955, Rev. Richard J. Toner was appointed the department's first chaplain by the Board of Fire Commissioners. Three years before, Toner had helped form the Fire Department Holy Name Society. For 15 years, he officiated at numerous fire service functions, from funerals to promotion and award ceremonies. Seated with Toner are firefighter Edward Fitzgerald (left) and Raymond Weiderhold (a police lieutenant). Standing are Battalion Chief Raymond Donnelly (left) and Michael McCaffrey (a police lieutenant).

Two proud men view a training evolution in the summer of 1955 at the fire department's proving grounds on Chestnut Street. Andrew J. Flannagan (left), chief training officer, and Chief Thomas J. Collins, who served as drillmaster for many years, both played a major role in developing the training site. Together, they issued the first *Manual of Standard Operating Procedures* to all officers and firefighters.

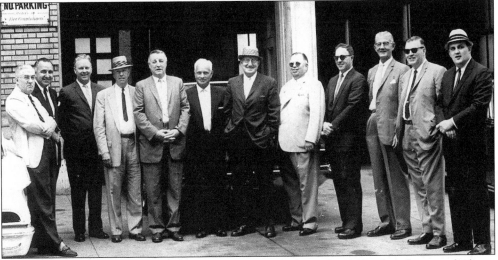

Taken in front of fire headquarters on Court Street in the early 1960s, this photograph shows some of the people who had an influence on public safety in the city of New Haven. From left to right are Charles T. McQueeney, managing editor of the *New Haven Register*; James DeAngelis, who later became a fire commissioner; Francis J. Sweeney, assistant chief; James J. Carter, fire commissioner; Francis J. McManus, chief of police; Nicholas Velardi, fire commissioner; Thomas J. Collins, chief; Edmund Markiewicz, fire commissioner; unidentified; Raymond J. Egan, assistant police chief; James P. Shanley, fire commissioner; and James Dahill, fire commissioner.

In 1955, three Bohan brothers were commanding officers in the department. Shown in the photograph are, from left to right, Capt. Charles I. Bohan, who started his career in 1925; Lt. Edward Bohan, who came aboard in 1946 after serving in the army as a lieutenant during World War II; and Lt. James Bohan, who joined the department in 1928. Over the years, there have been many families with brothers, fathers, and sons within the department.

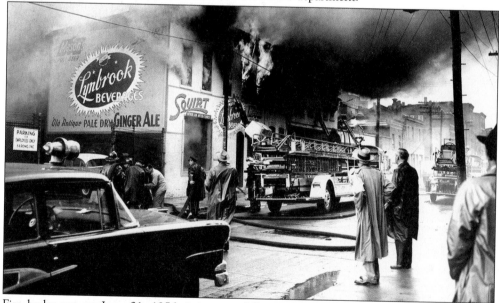

Fire broke out on June 21, 1956, in a second-floor storage area at the Lynbrook Beverages, 92 Commerce Street, located in a thickly settled business district. The blaze, called in at 1:09 p.m., went to three alarms, injured three firefighters, and took over an hour to bring under control. The entire second floor and roof were gutted. The bottling works was to be demolished the following year as part of the Oak Street redevelopment project. (Photograph by Mongillo's Studio.)

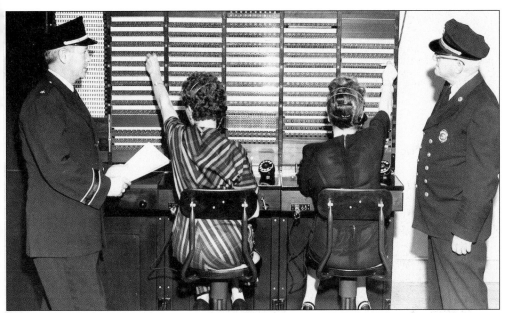

The new Fire-Police Communications Telephone Reporting system went into service at the end of 1956. Francis McManus (left), police chief, and Thomas J. Collins, fire chief, check out the new switchboard, located in the hall of records on Orange Street, as Elizabeth Timensky (left) and Marguerite McNeil work the board. The arrival of telephone reporting spelled the end for the Gamewell fire-alarm telegraph system, as 400 alarm boxes on city streets were targeted for removal. A reduction in false alarms was expected.

Lt. Walter Brocar, commanding officer of Engine Company No. 12, verifies the teletype before responding to an alarm dispatch in 1957. Emergency calls announced over the station's loudspeaker came directly from the nerve center at the Fire-Police Communications Center. One component of the system was a shortwave radio located in the station watch booth. The commanding officer was responsible for checking the location logged on the teletype before leaving the station.

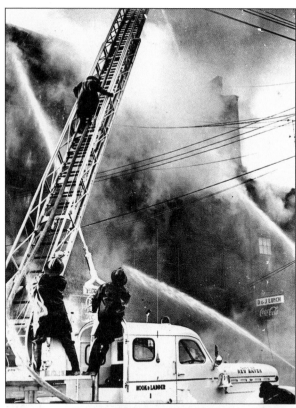

On January 24, 1957, the sky over New Haven was filled with thick black smoke and the air fouled by the stench of a looming death scene. At around 3:00 that afternoon, a blaze broke out in the four-story structure known as the Hugo Building, at 62 Franklin Street. Fifteen workers perished that day, most of them from severe burns. It was the worst loss of life from fire in the city's history.

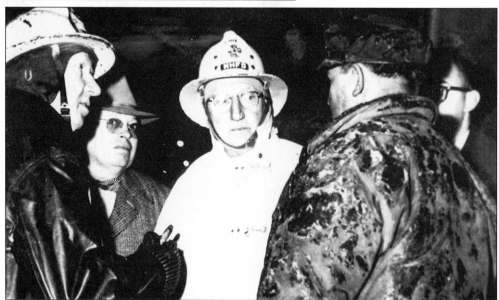

Chief Thomas J. Collins (center), his face reflecting the tragic circumstances, is briefed after calling for all off-duty firefighters to report to the scene of the four-alarm fire on Franklin Street. Collins was in the forefront in dealing with the blaze from the initial alarm, by which time the fire was already burning out of control. Later, as he was near exhaustion from the long ordeal, Collins was ordered to bed rest by Mayor Richard C. Lee.

Firefighters completely surrounded the blazing Hugo Building to prevent the flames and embers from spreading to adjoining structures. Fire companies with hose lines fought the fire from neighboring rooftops, and tons of water were pumped into the building to subdue the fire. The situation grew even worse when temperatures dropped to the freezing mark as the evening hours approached. In the end, the structure was condemned and torn down.

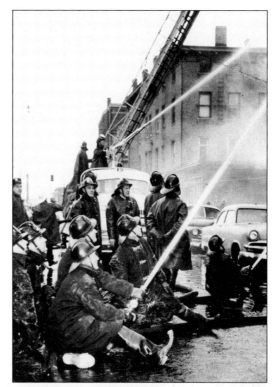

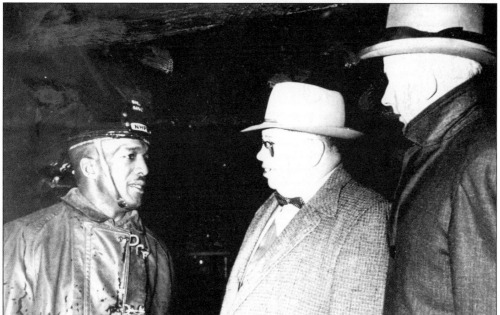

At the height of the Franklin Street fire, James Curry (left), an aide to Chief Collins, confers with Edmund Markiewicz (center) and Charles J. Gill, chairmen of the Fire Commission and Police Commission, respectively. One among the many heroic citizens and firefighters at the scene, Curry is credited with leading several women out of the blazing building and for positioning a piece of fire equipment in a confined, strategic spot.

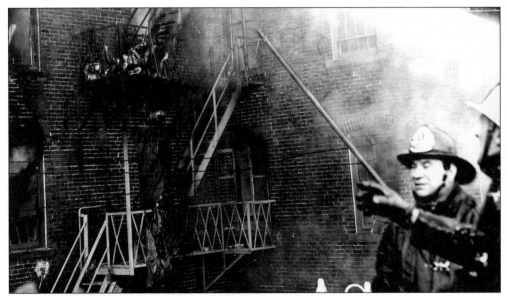

Several victims of the Franklin Street fire lay on the landing of the second-floor fire escape after being caught by flames from the windows. Many of the deceased had worked in the upper-floor dress shops. The building continued to smolder as firefighters wet down the ruins. Constructed in 1871, the Hugo Building did not have a sprinkler system. It had already been slated for demolition later that year to make way for a highway project that cut through the Wooster Square neighborhood.

One of the casualties, suffering burns over 80 percent of her body, is shown under treatment at the Hospital of St. Raphael. She later died. Ambulances had brought many burn victims to the hospital's emergency room. Faces were blackened from sooty smoke, and the smell of burnt flesh permeated the corridor. Doctors and nurses worked around the clock. Of the five people most seriously burned, only one survived.

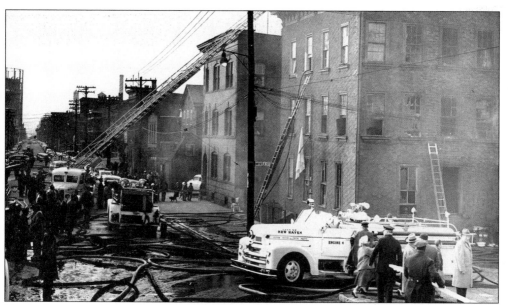

Fire broke out at 6 Myrtle Street on the morning of December 12, 1954. Flames raced up the stairs to the third floor after the fire had spread from a defective oil burner on the first floor. Three residents, some of them suffering burns, jumped from second-floor windows to escape the blaze. One resident tied sheets together and slid down the side of the building, while firefighters escorted others out of the building over ladders.

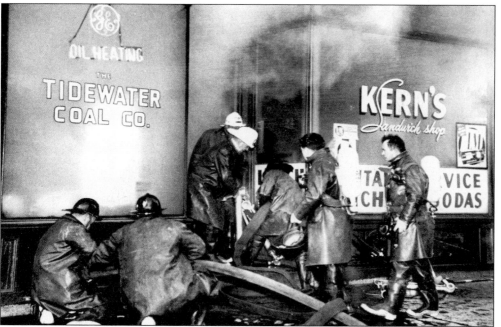

More than 50 people—employees and patrons of eight businesses—quickly emptied the building at Crown and Orange Streets during the morning of January 7, 1956. Heavy smoke filled the structure as firefighters faced a two-alarm battle that caused $10,000 in damage. Engine Company No. 12 personnel, ready to move in with Scott Air Paks, are stationed less than 100 feet from the building.

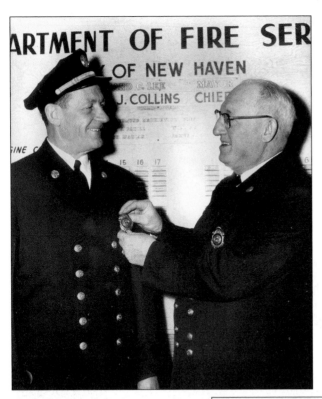

Chief Thomas J. Collins placed a promotional badge on Deputy Chief William F. Gould on March 13, 1957. Gould joined the department in 1929, made lieutenant in 1943, rose to captain in 1945, and became battalion chief in 1950. He came to the department in the thick of the Depression era and was one of the toughest and most knowledgeable "smoke eaters" of his time. Gould was one of the first to use the newly adopted gas mask at Engine Company No. 12 in 1943.

While on duty at Engine Company No. 12's station at 47 Crown Street, Lt. Michael Bohan and firefighters Edward Lawlor and John White spotted flames on the third floor of the Goodwill Industry, located near the firehouse. The engine company responded on a still alarm, followed by a full box alarm at 4:39 on October 9, 1957. Moments before the fire ignited, handicapped employees had departed the building for the day.

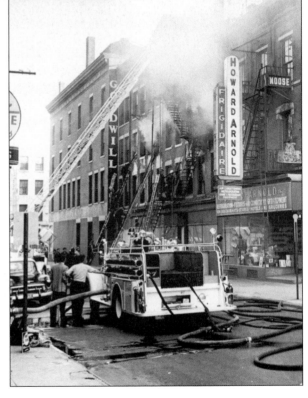

When Capt. Frederick W. Kaiser retired on October 25, 1957, he left behind a legacy as the one person who knew more about the workings of a Seagrave fire engine than anyone. After a solid run as a firefighter, Kaiser was tapped to eventually head up the Repair Division. In the early 1940s, Fred was the person who, by trial and error, gave all the apparatus a new look. Painting the traditionally red fire apparatus white was a radical departure in that day and age.

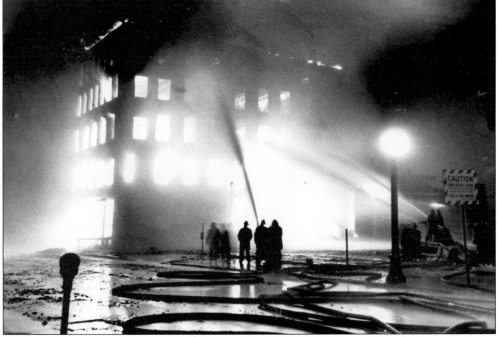

During the dark, early hours of December 4, 1957, a three-alarm fire destroyed a five-story building known as the Old Printing House, on Meadow Street. The empty structure was due for demolition to make way for a connector road off the new Connecticut Turnpike. The spectacular blaze cast a tremendous red glow in the sky. Two men were seen running from the building prior to the fire.

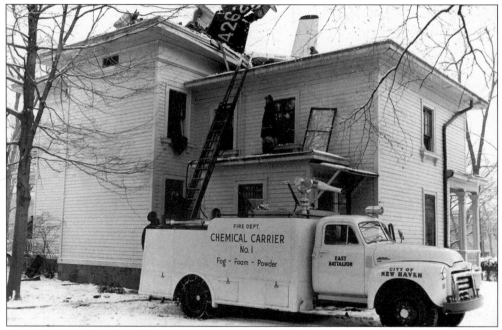

A single-engine Beechcraft Bonanza veered out of a swirling snow squall and careened into the roof of 980 Whalley Avenue, Westville, on December 12, 1957. Capt. Hans Fredericksen and firefighters from Engine Company No. 15 smashed the windows of the downed craft to remove the two injured occupants to awaiting stretchers. The alert pilot had turned off the ignition before the crash, and fire streams kept the leaking gasoline from igniting. (Courtesy of Patry/Carr Studios.)

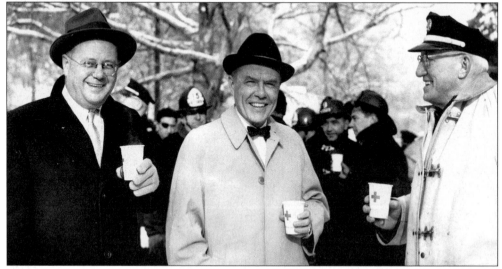

With the plane crash incident now under control, city officials and firefighters pause to enjoy a cup of coffee. The American Red Cross disaster services provided coffee and sandwiches to fire, police, and other salvage workers in subfreezing temperatures at the scene. Here, Board of Aldermen president William O'Connell (left), Mayor Richard C. Lee (center), and Chief Thomas J. Collins enjoy a chat while, in the background, firefighters from Engine Company No. 15 and Engine Company No. 9 warm up before finishing their tasks.

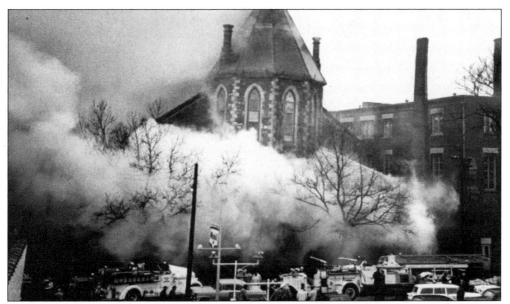

The four-alarm fire at St. Mary's Church, Hillhouse Avenue, on February 27, 1958, started in the basement area and was confined to the Temple Street side of the structure. Heavy afternoon traffic, rain, and streets narrowed in places by snow piles along the curbs combined to create a major traffic snarl during the blaze. An interior wall of stone, directly to the rear of the main altar, prevented the fire from spreading through the church.

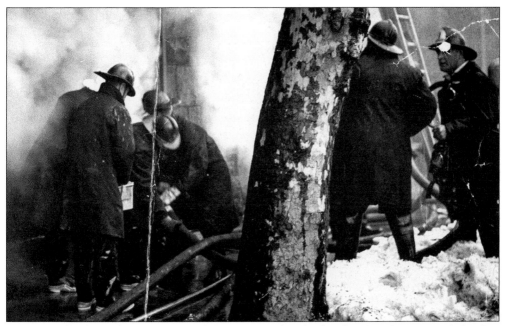

Dense smoke pours from the rear of St. Mary's Church shortly after discovery of the fire. Firefighters laddered the rear of the structure, brought in a maze of charged hose lines, and donned breathing equipment during their struggle to contain the fire. At the extreme right in this view, Lt. Oakleigh Stickle gets ready to enter the basement area. He was seriously burned while combating the blaze.

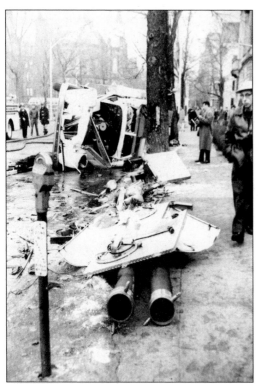

As Engine Company No. 2 responded from Central Station to a reported structural fire at the Hotel Duncan, Chapel Street, the rig was hit by an automobile at the intersection of Elm and Temple Streets on the morning of February 14, 1959. Driver Charles Mauro, 63, was thrown from the apparatus in the accident and died from crushing injuries to his head and chest. Firefighter William Carey, 34, suffered multiple injuries and died five hours later at St. Raphael's Hospital.

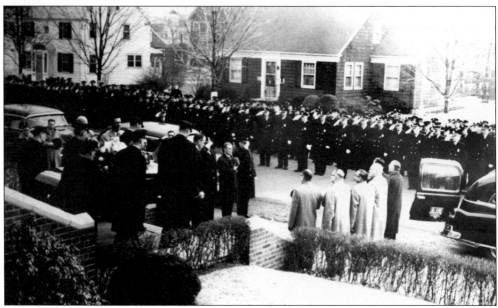

The funeral mass for firefighter Charles Mauro was held at St. Vincent de Paul Church in East Haven. Outside the church, firefighters line the street and salute the casket as the funeral procession continues on to the cemetery. William Carey's funeral mass was held at St. Francis Church. Full department honors were given to both men, and flags at all fire stations were flown at half-staff in their memory. Central Station, where both men had been assigned, was draped in black.

More than 1,500 people, including business leaders, state and city officials, and firefighters and officers from around New England, were on hand for the annual Field Day, held at the training center on Hamilton Street. A demonstration of extinguishing tactics used to combat flammable-liquid fires was one of the many events that impressed the large crowd on June 11, 1960. The fire college and training center in New Haven had a reputation second to none.

Construction of the Woodward Avenue station and its dedication on June 25, 1960, marked the return of Engine Company No. 5, which had been decommissioned in 1940. The establishment of the 32nd Ward Firehouse had resulted from a city pledge to provide improved fire protection when the Annex community was absorbed into the city in 1958, through action by the Connecticut General Assembly. The fire company had major responsibilities in covering the waterfront area, which was home to numerous bulk fuel storage facilities. (Courtesy of Jack Stock Studio.)

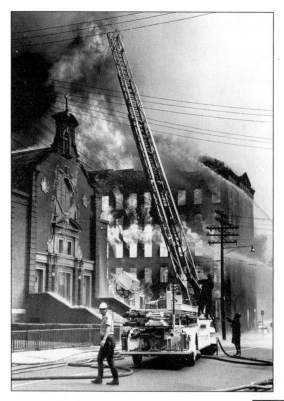

On August 29, 1960, the Wooster Square neighborhood faced another fire challenge when a 100-year-old structure at the corner of Chapel and Chestnut Streets erupted in flames. The vacant building, which once housed the Shoninger Piano Factory, was set ablaze after sparks from a welder's torch ignited combustibles. All the windows had been removed from the building since it had been earmarked for demolition to make way for the Wooster Square redevelopment project.

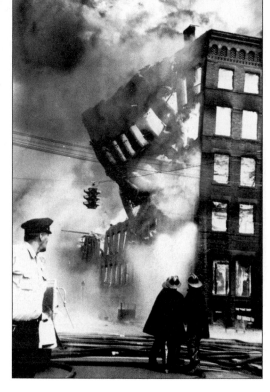

This dramatic award-winning photograph by fire department photographer Lt. Alfred Bysiewicz captures the collapse of the Chestnut Street side of the Shoninger building. A tremendous rumble shook the neighborhood as the wall crashed to the ground. The oil-soaked floors of the factory loft, which had been formerly occupied by several other manufacturers, contributed to the rapid spread of flames that quickly enveloped the entire structure.

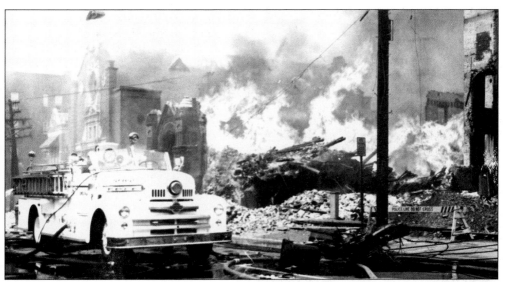

All that remained after the walls of the Shoninger building collapsed were the former entranceway to the loft and an elevator shaft. St. Louis Church can be seen at the left. Almost half of the roof of the church burned through, and priceless stained-glass windows on the Chestnut Street side broke from the intense heat. Many firefighters suffered from heat exhaustion and were treated at the fire scene.

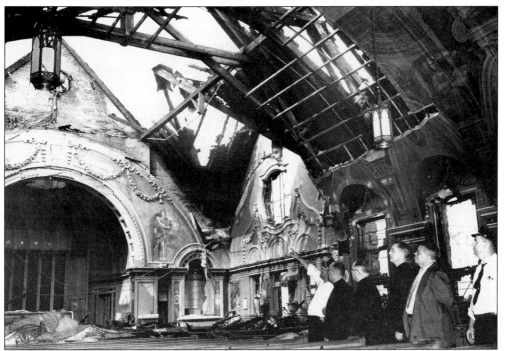

One hour after the Shoninger building went up in flames, the fire leaped across Chestnut Street to St. Louis de France Roman Catholic Church and the parochial school behind it. Fire officials and priests were photographed as they viewed the destruction at the church. The front six rows of pews, under the burned-out roof, were knee-deep in ashes and rubble. Firefighters removed precious statues from the church before the roof caved in.

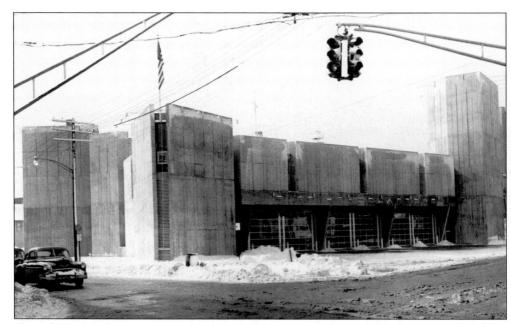

Central Fire Headquarters, a modernistic building, was dedicated on February 4, 1962. The structure was dubbed "the gateway to Wooster Square redevelopment." The Milner Hotel had formerly occupied the property. Engine Company No. 2, Engine Company No. 4, and Hook and Ladder No. 1 moved to the new headquarters after abandoning their Olive Street station, which had been in use since 1907. The office of the chief and fire marshal relocated here from the Court Street headquarters it first occupied in 1913.

The first Olympic Development Track Meet for Greater New Haven high schools, sponsored by New Haven Fire Department American Legion Post No. 132, was held at Bowen Field in June 1962. Standing behind the trophies are, from left to right, Alan Turner (post adjutant), Thomas J. Collins (chief), Donald F. McCarthy (post commander), William J. Hartigan (co-chairman), and Francis J. Sweeney (assistant chief). The Olympic torch was lit at the New Haven Green and then carried several miles to the athletic site.

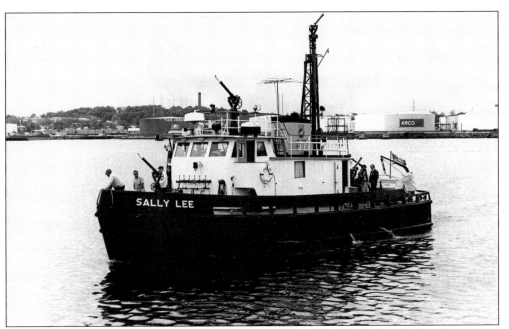

On September 29, 1962, New Haven fireboat *Sally Lee* was commissioned with a proper ceremony, open house, and demonstration of its flexibility in handling waterfront fires and salvage and rescue operations. The vessel provided the hub for harbor fire defenses, and its addition served to elevate the department's status as one equipped with the most modern marine apparatus. The first commanding officer of the vessel was Lt. Thomas Comeau, a navy veteran of World War II. (Photograph by Michael Vanacore.)

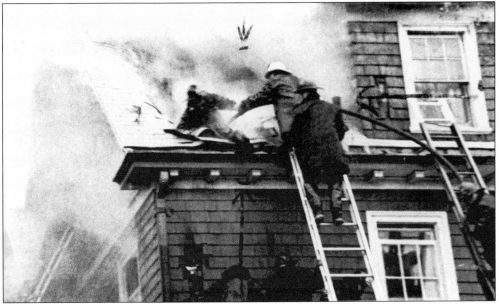

Lt. John Reardon of Engine Company No. 3 fell through a fire-weakened roof during a two-alarm blaze at 830 Elm Street on November 6, 1962. As he was cutting a hole in the roof, Reardon fell four feet into the attic. He is shown being pulled out of his dilemma by a fellow firefighter, who had thrust a hose line into the hole to aid Reardon.

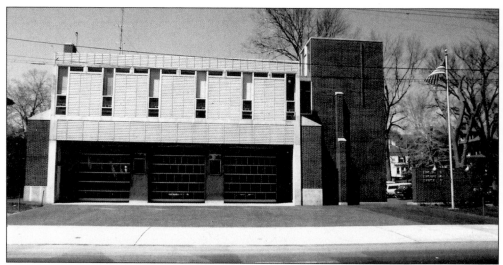

The new Whitney Avenue station was dedicated on July 27, 1963. The building became the quarters of Engine Company No. 8, Engine Company No. 14, and Hook and Ladder Company No. 6. The consolidation of these companies into more modern facilities further increased the efficiency of the fire department. The old station on Edwards Street, which had been occupied by Engine 8 since 1874, was sold and became a restaurant, while Engine 14's former Highland Street station became a day-care center.

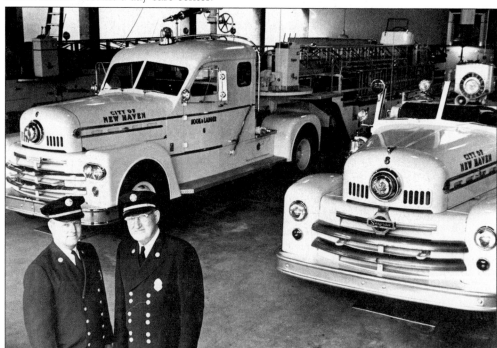

Whenever the top brass visited a fire station, it was the watchman's duty to call all hands to the apparatus floor. On this occasion in 1964, Assistant Chief Francis J. Sweeny (left) and Chief Thomas J. Collins paid a visit to the Whitney Avenue station, home of Engine Company No. 8 and Hook and Ladder Company No. 6. Inspection of men and quarters by chief officers always ensured that the companies were maintaining a strict semi-military discipline.

It took Francis J. Sweeney 21 years to make the full transition from newly appointed firefighter to chief of department. Sweeney first joined the New Haven Fire Department on August 30, 1944, and two decades later, on July 1, 1965, he was tapped to lead the department following the retirement of Chief Thomas J. Collins. One of the most significant phases of Sweeney's career was when he served as head of the Fire Training School, which had a long and honorable history dating back to its modest beginnings in 1891. The New Haven training school was one of the first facilities in the country to offer any sort of formalized instruction. During Sweeney's 13-year tenure as chief, the department flourished—maintaining its already established reputation in fire suppression, and blazing new trails in public safety. Chief Sweeney was responsible for keeping the Central Medical Emergency Dispatch alive during its infancy. The program continues to coordinate emergency medical response to 20 participating towns in the New Haven region. Under Sweeney's direction, a comprehensive anti-arson strategy was developed that attracted nationwide attention.

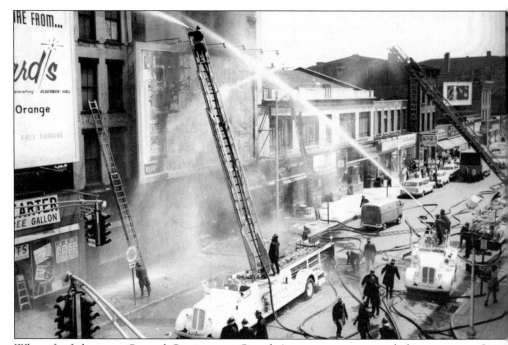

When firefighters at Central Station, on Grand Avenue, came around the corner to State Street on June 18, 1963, they were greeted by a mass of flames coming out the front of the Lincoln Furniture Company. The three-alarm blaze erupted shortly after 2:00 p.m. in a rubbish pile near the elevator on the building's first floor. Twenty people scrambled out the rear of the furniture store and Sterling Restaurant next door to escape the fast-spreading fire.

Forty-seven years of distinguished service came to an end when Assistant Chief Robert P. Grey retired on October 31, 1965. At his retirement, Grey was presented with a three-foot model of the old Goffe Street Bell Tower, which was used from 1894 to 1929 as a signaling device to notify firemen of a fire and its location. When he joined the fire service in 1918, one of Grey's responsibilities was to keep the tower in operational readiness.

The fire department marching contingent passes the reviewing stand in front of city hall during the annual St. Patrick's Day parade in 1966. Mayor Richard C. Lee (on the stand with his daughter Sally Lee) gives the group a smile of approval. To the mayor's left is Dr. John McDevitt, supreme knight of the Knights of Columbus.

Promotions to the rank of battalion chief took place on September 28, 1966, when four senior captains were elevated to the chief officer rank after successfully passing the civil service exam. With Chief Francis J. Sweeney (far left) looking on, Mayor Richard C. Lee, who administered the oath of office, congratulates, from left to right, Walter Brocar (drillmaster), Thomas McNamara, Thomas Connelly, and Dennis Griffin. Brocar remained in charge of training while the others were assigned to fill the battalion vacancies.

In 1967, the department acquired these two customized Chevrolet Step-Vans for service as Emergency Unit No. 1, assigned to fire headquarters on Grand Avenue, and Emergency Unit No. 2, stationed across town at the Ellsworth Avenue firehouse. Pictured with the vans are on-duty EMS technicians, from left to right, John Bohan, Gerald Enright, John Esposito, and John Wynne. The two units were manned around the clock on the three fire department divisions working the 56-hour work week.

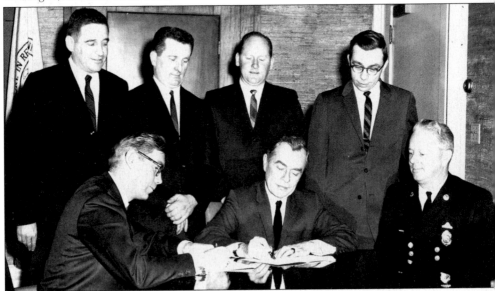

Negotiations between the city of New Haven and Firefighters Local No. 825 reached a positive conclusion in October 1966. Part of the four-year agreement was a reduction in the work week from 56 hours to 42 hours. Mayor Richard C. Lee (center) and Robert Gilhuly (left), president of Local No. 825, pen their signatures on the contract. Chief Francis J. Sweeney is at the right. Looking on are union officers Aaron Barstein, John Rourke, and Daniel Kirby and city negotiator Dennis Rezendes.

# Six

# LABOR UNREST

Mayor Richard C. Lee hosted a luncheon at the Quinnipiac Club on January 31, 1967, to mark the promotion of 11 men to the rank of captain. Deputy Chief William Gould was also promoted to the rank of assistant chief at the gathering. From left to right are Eugene F. Sullivan, John J. Conlon, George Grandinette, Matthew J. Lyons, Dennis J. Heins, Leonard Rizzo, John P. Reardon, Henry I. Torgerson, Alfred R. Bysiewicz, Albert J. Serletti, and Donald F. McCarthy.

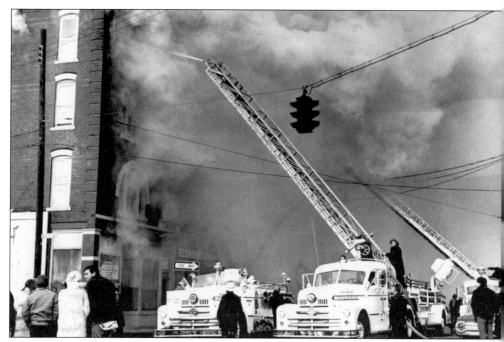

Another fire in the Hill section brought firefighters to 571 Congress Avenue on February 24, 1967, where they encountered a stubborn blaze in a four-story brick business-residence structure. When flames shot out windows of the fourth floor, it gave the appearance of a blast furnace under full draft. Paul Henig, driver of Hook and Ladder Company No. 2, is seen controlling the ladder pipe from the aerial ladder platform. More than 20 people were left homeless following the fire.

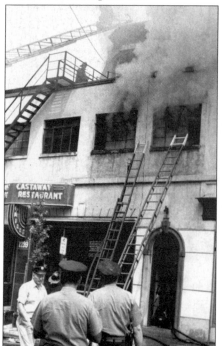

It was September 1, 1967, and Engine Company No. 9 was returning from a fire and turning from Howe Street into Chapel Street when the men were greeted by the sight of heavy smoke and flames coming from the upper-floor windows above the Castaway Restaurant, at 1243 Chapel Street. The company radioed for a box alarm and swung into action. John Zacks (left), pump operator, is joined by two police officers in front of the structure.

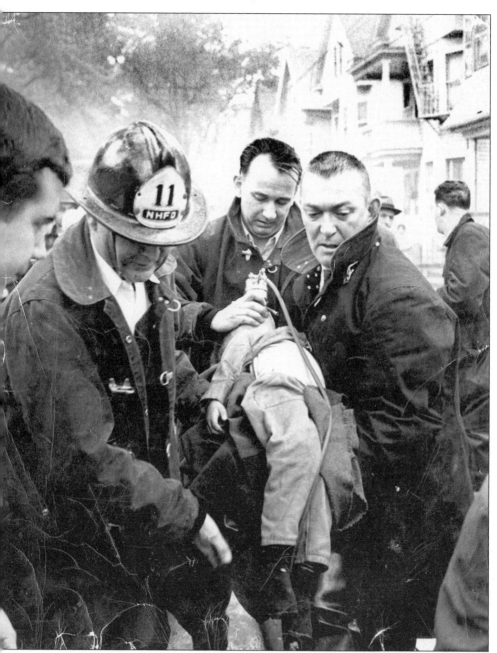

Two young children died in a smoky fire at 11 Hurlburt Street on November 2, 1967. The brother, age five, and sister, age four, were found under a bed in a rear room by firefighters James Reardon and Robert Mazurek, who gave the children mouth-to-mouth resuscitation while carrying them from the building. In the above photograph, oxygen is administered to the boy by Gerald Enright (center) while Capt. Eugene Sullivan (wearing helmet) and Lt. Clifford Lynch carry the child. The young girl was attended to by John Mulligan, who vainly gave her mouth-to-mouth resuscitation, and Deputy Chief Paul Heinz. The children had ignited the fire while playing with matches. Subsequently they became frightened and hid under the bed to get away from the smoldering fire. (Photograph by George Keeley.)

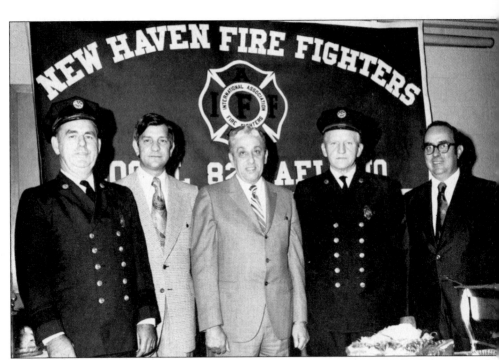

The Fire Prevention Week business luncheon, held at the Fire Training Hall, always drew a bi
crowd. In 1969, New Haven Firefighters Local No. 825 was given an opportunity to present t
the audience a dramatic film that had been produced by the International Association o
Firefighters. From left to right are Fire Marshal Thomas Lyden, Police Chief Biagio DiLieto
Mayor Bartholomew Guida, Assistant Chief John E. Smith, and Chamber of Commerc
representative Richard Knott.

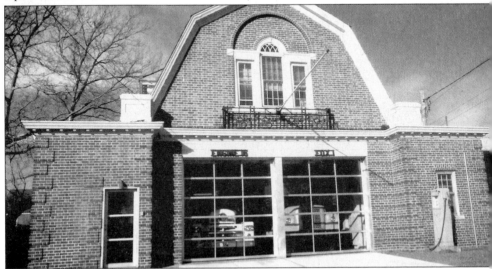

When the Municipal Airport opened for operation on August 29, 1931, Engine Compan
No. 16, located at 510 Lighthouse Road in the Morris Cove community, was first due at Airpo
Box 4444. In 1970, a new International Harvester Ansul Magnum crash vehicle was assigne
to the station, replacing "Little Mo," a crash truck manufactured by Young Fire Equipment. Th
new response vehicle was known as "Fox One."

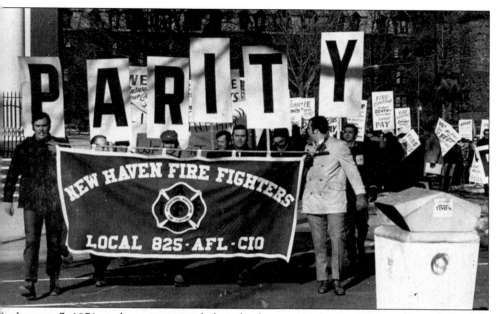

On January 7, 1971, with temperatures below the freezing mark, New Haven Firefighters Local No. 825 officials and its 400 members stormed across the New Haven Green and on to city hall for the beginning of a week-long picket over stalled contract negotiations. The union's protest later expanded to a job action and a full-page ad in the *New Haven Register*, which led to a successful conclusion to the firefighters' quest for pay parity with the police department.

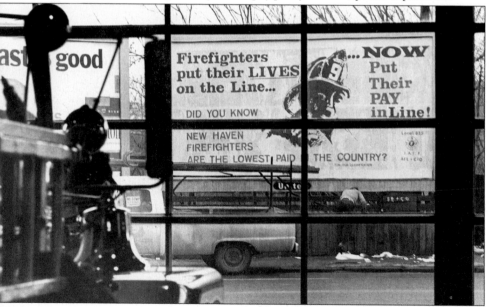

In 1971, New Haven Firefighters Local No. 825, affiliated with the International Association of Firefighters AFL-CIO, took its contract plight to the public. Nine billboards, all bearing the same message, were placed at strategic locations throughout the city. This billboard, opposite fire headquarters on Grand Avenue, reminded all visitors to the area of the contract impasse. Connecticut Bus Company carried a similar message on many of its vehicles that traveled through the city. The contract dispute was resolved amicably.

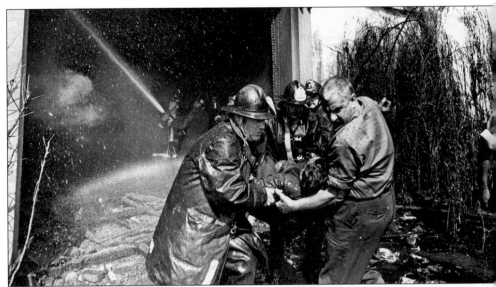

A smoky three-alarm fire on a hot August 25, 1971, gutted a warehouse at West and Thor Streets and caused injury to five firefighters. After sustaining a head concussion from a falling overhead door track, Lt. Germano Natalano of Engine Company No. 11 is carried ou unconscious to be transported to the hospital. The heavy smoke blanketed the area, creatin visibility problems for the arriving fire companies. (Photograph by Kenneth Randolph.)

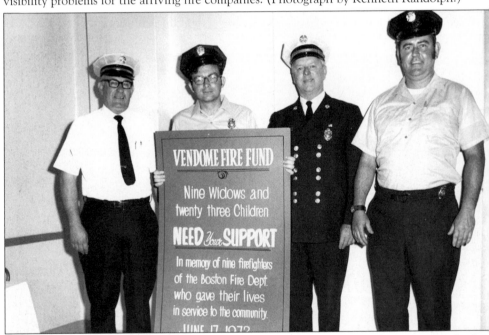

New Haven Firefighters Local No. 825 gave a helping hand to the Vendome Fire Fund, whic was established for widows and children of nine Boston firefighters who had lost their lives a fire at Boston's Vendome Hotel on June 17, 1972. After the fire had been extinguished, th building collapsed on top of the firefighters. Pictured from left to right are Local No. 825 William J. Hartigan (president), Martin J. O'Connor, Chief Francis J. Sweeney, and Joh Bailey (secretary).

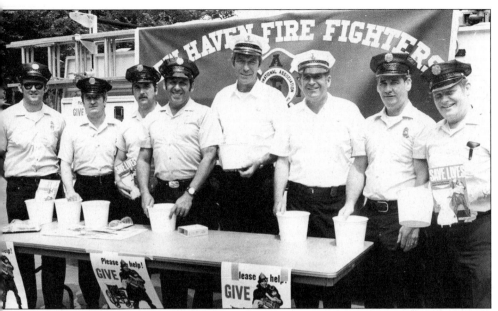

Firefighters from Local No. 825 were on the New Haven Green on June 16, 1973, to kick off their summer-long Muscular Dystrophy Drive. Proceeds raised by the union were donated to the Jerry Lewis National Telethon the following Labor Day. From left to right are James Taylor, John Rourke (president), John Esposito, Anthony Gambardella (secretary-treasurer), Lt. William Mooney, Lt. Aaron Barstein, Robert Foley, and Donald Doherty.

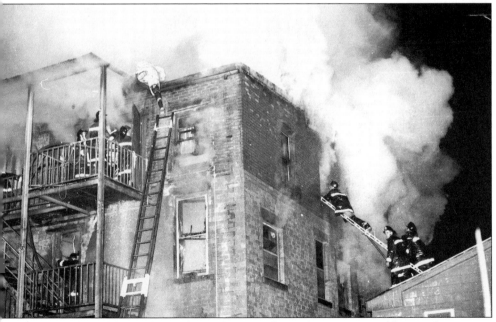

The worst residential loss of life to fire in the city of New Haven occurred late in the evening of May 7, 1974. Eight people, including a pregnant woman and two infants, were killed in a blaze at a four-story duplex apartment at 30 Castle Street. Eight people leaped from the building in the fast-spreading fire that was fueled by gasoline from an arsonist. Firefighters arrived on the scene to screams of "Fuego! Fuego!" (Photograph by William Seward.)

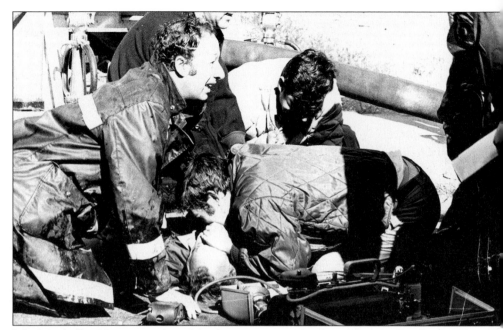

John Mitchell, a 23-year member of the department, was fatally stricken on October 8, 1974, after firefighters had rescued nine people from a two-alarm blaze at 46 Legion Avenue. Mitchell collapsed with an apparent heart attack while operating the pump of Engine Company No. 2. Fellow firefighters worked feverishly in their attempt to revive Mitchell before he was rushed to St. Raphael Hospital. He was also a veteran of the U.S. Navy. (Photograph by John Mongillo Jr.)

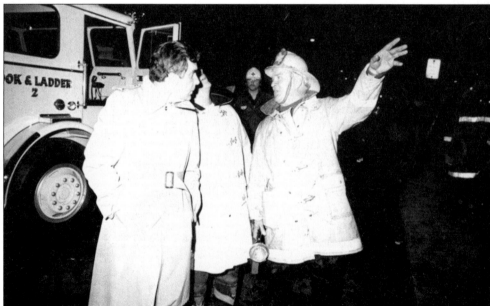

Mayor Frank Logue (left) is on the scene in 1976 at another multiple-alarm fire in the Hill section of the city. Paul W. Heinz (right), assistant chief of operations, takes command at the incident, updating the mayor on the conditions confronting the firefighters. An American Red Cross official is in the background, ready to assist with temporary housing for the residents of the ravaged building.

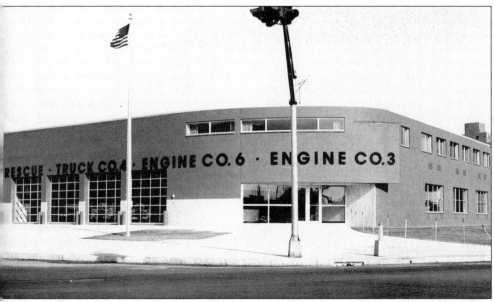

The official opening of the Dixwell Fire Station (above), at Goffe and Webster Streets, on December 20, 1974, marked a new era in public safety. The operations of Engine Company No. 6 and Hook and Ladder No. 4 (both previously stationed at Dixwell Avenue) and Engine Company No. 3 (formerly stationed at Park and Elm Streets) were centralized at the new station. The two vacated stations were subsequently sold. The Park and Elm location became a popular restaurant. In the photograph below, the apparatus response from the station was rapid and swift as the three companies combined made Dixwell the busiest station in the city. The spacious apparatus floor, in clear view of the watch booth, and the long apron in front of the station provided officers and firefighters with a safe exit from the structure.

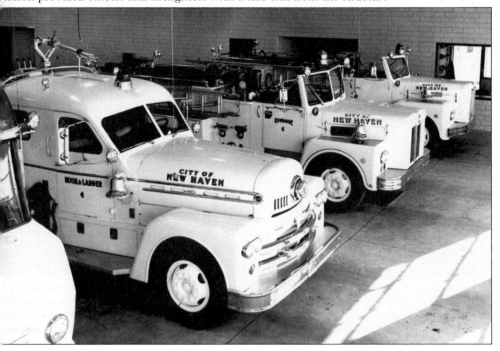

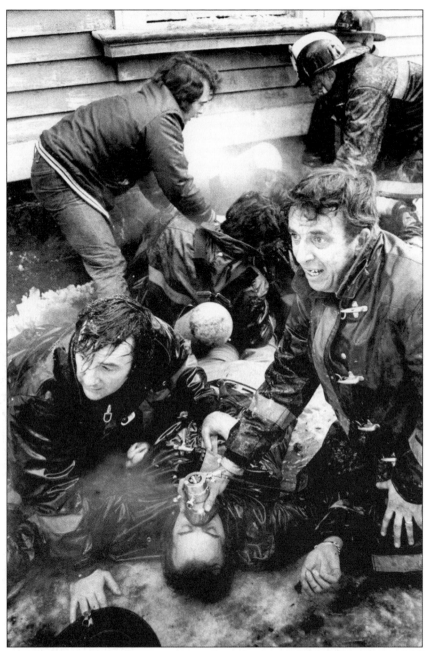

Emotional strain and exhaustion are registered on the faces of firefighters Kevin Miller and David Whitney as they work on colleague Bruce Green, who had been pulled from a basement window after being overcome while battling a three-alarm blaze at the Young Israel Synagogue on Norton Street. In the background, two other firefighters, Lt. Robert King and Robert Armstead, are pulled out through the basement window. Members of Engine Company No. 9 were trapped when the stairs behind them collapsed and their breathing equipment ran out of air. This photograph, taken on January 24, 1976, by *New Haven Register* photographer James Meehan, won second prize in the 12th annual media awards competition sponsored by the International Association of Firefighters.

*Seven*

# THE GLORY YEARS

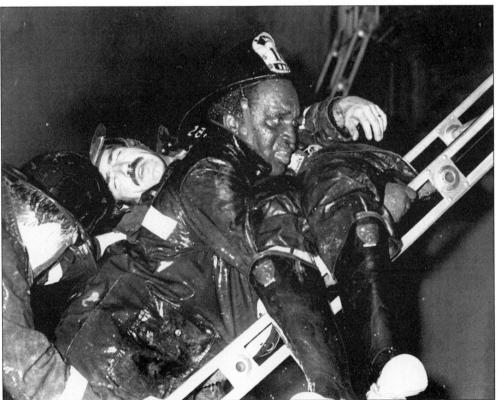

"He Ain't Heavy—He's My Brother" is the caption of this award-winning photograph taken on May 9, 1979. Two children died in a two-alarm fire at 47 Grand Avenue in the Fair Haven section of the city. At the scene, Lt. George Sweeney carries unconscious firefighter Edward DeChello down the ladder after he was overcome by smoke on the second floor. John Doyle assists in the rescue. (Photograph by John Mongillo Jr.)

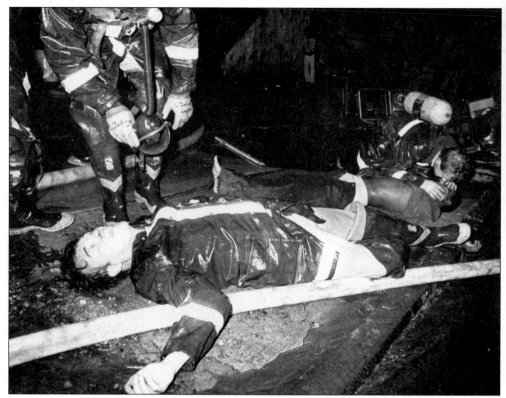

One of two children pulled from the smoky fire at 47 Grand Avenue is given mouth-to-mouth resuscitation. Heroic efforts by firefighters failed to save the two children, who died from smoke inhalation. One firefighter lies on the hose, unconscious from heat exhaustion, as water gushes through the street gutter. (Photograph by John Mongillo Jr.)

"Charge the line" is the call from Lt. Boris Starzyk as firefighter Kevin Miller, on the nozzle, prepares to advance the hose into the structure. The fire took place on September 28, 1978, at 70 Admiral Street in a vacant structure formerly occupied by the Forbes Halfway House. Firefighters at the Dixwell Avenue station spotted the smoke at 5:25 a.m. and promptly responded. The interior of the structure was gutted. (Photograph by Richard F. Mei.)

Francis J. Sweeney bids farewell as he retires on August 30, 1978, after serving as chief of department for 13 years. In rising up through the ranks, he once served as drillmaster and stated, "A better trained firefighter, a more progressive fire department." During his tenure, Sweeney, shown here with Battalion Chief Alfred Bysiewicz and firefighters at Central Station, advanced the department in the areas of equipment modernization, safety of firefighters, department facilities, and long-range planning.

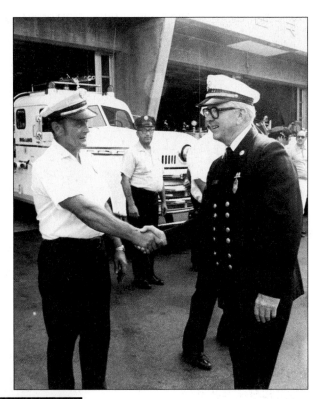

Biagio DiLieto, newly elected mayor, is briefed by Chief John Reardon at a three-alarm fire on February 20, 1980. The blaze broke out in a vacant two-story building, previously occupied by Grocers Wholesale Outlet, located on the bank of the Quinnipiac River on Front Street. The structure was fully involved when firefighters arrived. The fireboat responded from the water side, pouring tons of water into the 70-year-old former factory building.

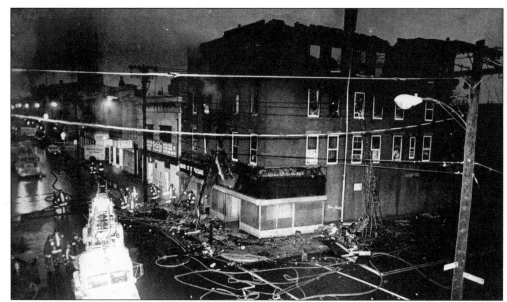

Two young children and an adult male were burned beyond recognition as a deliberately set fire gutted a four-story apartment building at 763–769 Grand Avenue on March 31, 1980. Two firefighters were injured. One suffered three broken ribs when a roof over a rear fire escape collapsed on him. At one point, two firefighters who were searching for victims became trapped in the raging inferno that was fueled by an accelerant. Happily, the pair escaped without injury. (Photograph by John Mongillo Jr.)

The eight-week-old Dalmatian puppy owned by Chief John Reardon and wife Barbara eyes a pair of boots as he sits on the front bumper of Engine Company No. 11 during the dedication ceremony for the new Howard Avenue station on September 15, 1980. A large crowd was on hand to tour the state-of-the-art building, located in the Hill neighborhood. (Photograph by Wayne Howe.)

112

The Fair Haven community prides itself on the fire protection afforded by the three companies that are assigned to the Lombard Street station. Engine Company No. 10 (a 1970 Maxim 1,000-gallon-per-minute pumper), Tactical Unit No. 2 (a 1981 Chevrolet Ranger), and Hook and Ladder Company No. 3 (a 1979 Seagrave 100-foot aerial truck) all respond out of the station with the east battalion chief. Tactical Unit No. 2 was formerly Engine Company No. 7. The firehouse was built in 1959 to replace an older station.

The 20th annual Retired Members Dinner and Awards Night was held on October 29, 1981, at the Annex YMA, on Woodward Avenue in the East Shore section of the city. From left to right are Assistant Chiefs Harold Owens and John E. Smith; Marine Glass, secretary-treasurer; John Bailey; Dusty Alwood, 3rd District vice president, IAFF; Edward Fitzgerald (rear); Anthony Gambardella, president; Rev. Raymond Barry; Mayor Biagio DiLieto; Bob Norman, WTNH-Channel 8 IAFF media award recipient; Walter Smith; Joy Palit, WTNH award recipient; and John Wynne.

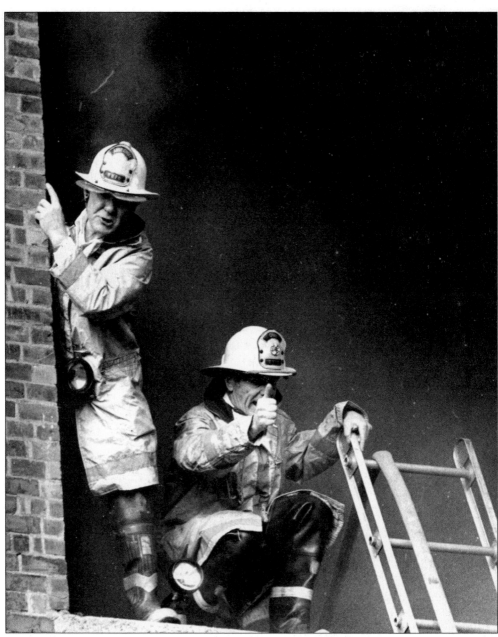

Assistant Chief Harold Owens (left) takes some air while Chief John Reardon, crouched at the ladder, hollers instructions to firefighters below during a three-alarm fire at the former Yale Brewery, at Ferry and River Streets, on March 17, 1983. Fourteen firefighters suffering from smoke inhalation and heat exhaustion were taken to Yale New Haven Hospital and St. Raphael Hospital. The hot, smoky blaze was confined to a second-floor refrigeration room insulated with cork. The accidental fire was started by workmen using a cutting tool. The vacant building was the showpiece of a $20 million Brewery Square project in the Fair Haven community that involved another structure being gutted and a vacant stretch of land along the Quinnipiac River. When completed, the brewery was converted into 102 rental apartments. (Photograph by Kirby Kennedy.)

Chief John Reardon (left) and his two key men, Assistant Chief John E. Smith (center) and Assistant Chief Harold Owens, enjoy a laugh on the set of Storer Cable Television. They are ready to take part in an interview on one of the 13 shows produced by the fire department's Office of Information and Community Service. The series centered on the activity of the fire service and was taped and broadcast in the spring of 1983. Below, Capt. Edward Flynn Jr. (left), show director Ralph Guardiano of Storer Community Television, and Lt. Donald Wilson (right) gave the set one last look before the cameras rolled for the next segment of the series. Flynn and Wilson produced the popular program that reached thousands of residents in New Haven, Hamden, and West Haven.

Lt. Michael E. Grant, assistant drillmaster, received the Firefighter of the Year award at the fifth annual dinner of Box 22 Associates, held on November 15, 1983. Grant was cited for several rescue attempts. He rescued a girl during the June 1982 floods; a man from a burning building on Elm Street; and a Minnesota man from a car that had been crushed in a truck accident on the Connecticut Turnpike.

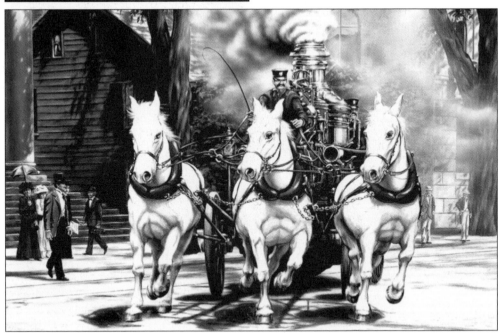

In 1910, photographer Charles Roos tried unsuccessfully to photograph Pres. Howard Taft's son at the Yale University graduation. After giving up, Roos used his last glass plate to capture a three-horse team pulling Steamer Engine No. 2 up College Street. Later, the developed plate reveals both the horses and young Taft. Artist Tony Falcone captured all the beauty of the photograph in 1982 when he painted and reproduced this dramatic scene for a work presented to former Mayor Richard C. Lee.

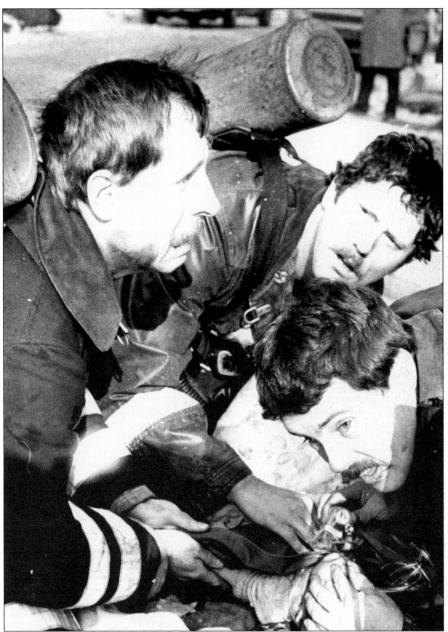

Anguish is written on the faces of James Stacy (left), Marvin Pope (center), and William Seward as they work to revive a four-month-old child at the scene of a house fire on Adeline Street, in the Hill neighborhood, on January 17, 1984. Lt. Ted Siedlarz and firefighter Michael McNamara kicked in doors and groped around in dense smoke to rescue the infant, who was not breathing when lifted from his crib. Flames were blasting out the windows of the second floor when the fire units arrived. The mother told firefighters that her child was in a back bedroom that was inundated with heavy smoke. The baby was handed over to New Haven Fire Department emergency medical technicians, who revived the child through cardiopulmonary resuscitation. The infant was then transported to Yale New Haven Hospital. (Photograph by Kirby Kennedy.)

Capt. Anthony L. Conforte, 55, was the 59th member of the department to die in the line of duty. He was commanding officer of Engine Company No. 5, which was first on the scene of a spectacular blaze on January 19, 1984. Conforte called for a second alarm as the fire raged out of control at the former U.S. Steel plant on Fairmont Avenue. While his company was lining in to the fire, Conforte suffered cardiac arrest and collapsed in the snow.

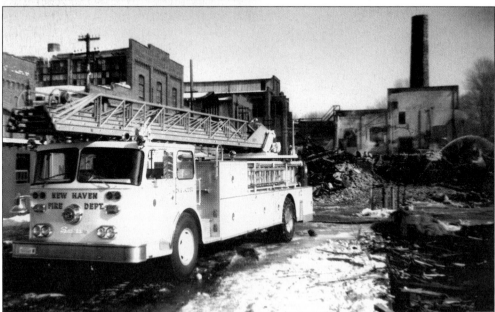

One building was left a burned-out shell and two others suffered some damage at the 34.5-acre complex before fighters were able to bring the blaze under control at the vacant U.S. Steel plant. Arson was the cause of the four-alarm fire that was first dispatched at 5:15 p.m. Efforts by firefighters were severely hampered by the winds, deep snow, and long distance from street hydrants to the location of the main fire at Building No. 8.

The Connecticut State Firemen's Association held its 101st annual convention from September 14 to September 16, 1984, in the city of New Haven. The CSFA was first organized in New Haven on May 22, 1844, and 12 of its presidents have been members of the New Haven Fire Department. The business portion and awards ceremony were held at the Park Plaza Hotel. One of the largest parades ever held in the city drew thousands of people from all over the state to view the many types of fire apparatus in the procession. The parade route started at State Street and proceeded down Chapel Street to Yale Avenue in Westville. A reception and presentation of trophies followed at Yale Field. The New Haven Fire Department American Legion Post No. 132 Color Guard led the parade. Donald McCarthy (left), the post adjutant, and Robert Callahan (right), commander, headed the group.

It is Sunday, March 10, 1985, and the wearing of the green marks the annual St. Patrick's Day parade in New Haven. Mayor Biagio DiLieto (center) is escorted by Police Chief William Farrell (left) and Fire Chief John P. Reardon as they near the reviewing stand on Church Street. Farther back is a contingent of New Haven firefighters, who will get a rousing round of applause when they pass by the large crowd in the Yale University area on Chapel Street.

Promotions to battalion chief and captain took place in April 1986 as Mayor Biagio DiLieto administered the oath of office to nine fire officers. From left to right are Assistant Chief John Smith, Chief John P. Reardon, Battalion Chief Anthony Gambardella, Capt. Donald Wilson, Battalion Chief Martin O'Connor, Capt. Thomas Quirk, Battalion Chief George Boucher, Capt. Timothy King, Battalion Chief Edward Flynn, Capt. Edward Fitzgerald, Battalion Chief Robert Baker, and Mayor DiLieto. (Photograph by Phil Papa.)

A new, 1986 Sutphen pumper-aerial ladder gets a polishing from firefighters Michael Celentano (left), Brian Sullivan (center), and Kevin Coyle. Engine Company No. 5 is assigned to the Woodward Avenue station in the East Shore section of the city. This state-of-the-art, $310,000 fire truck is equipped with a 65-foot aerial ladder, foam system, and a 1,500-gallon-per-minute pumping engine. The company is first due in at the fuel-storage tank farms. (Photograph by Michael F. O'Brien.)

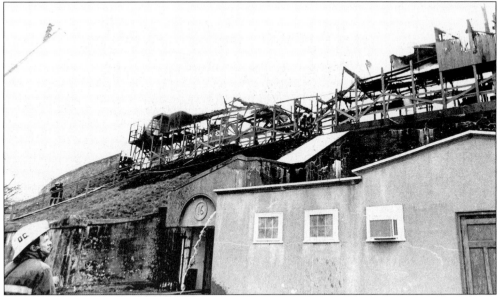

On the morning of November 2, 1986, the Yale Bowl press box was destroyed by an electrical fire that was discovered by a groundskeeper shortly before 6:30. Firefighters had to drop hose a long distance from the nearest hydrant to reach the blaze, which was fanned by winds. The 210-seat press box was filled the day before when the Dartmouth football team trounced Yale 39-13. At the lower left, Deputy Chief Donald McCarthy surveys the damage at the Westville athletic complex. (Photograph by John Mongillo Jr.)

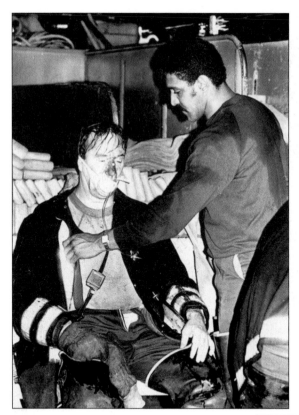

Firefighter Kevin Miller, suffering from smoke inhalation, is assisted by colleague Larry Zackery on the back step of the engine. On January 15, 1987, a three-alarm fire at the DeSimone Jewelers building, 1142 Chapel Street, routed three tenants. One was rescued from a ledge by firefighters. The blaze started in a first-floor ceiling, where a plumber had been soldering pipes. Flames were coming through the roof when the engines arrived. (Photograph by Stephanie Gay.)

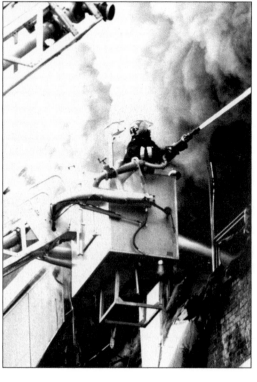

Eight firefighters were injured at the Starter Sporting Goods warehouse, 370 James Street, after a welder's torch set off a four-alarm blaze on July 8, 1987. Firefighter William Dixon guides the nozzle on Tower Ladder No. 1 platform at the peak of the fire. Structural and content damage totaled over $10 million. The fire spread by traveling up the pipe chase. The company had been designated a National Football League licensee three years earlier. (Photograph by Kirby Kennedy.)

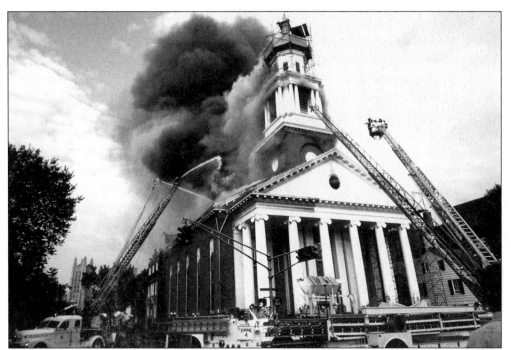

A four-alarm fire destroyed the upper portion of the historic First and Summerfield United Methodist Church on September 28, 1987. Damage to the 138-year-old church at Elm and College Streets was estimated at $2 million. The church's pipe organ, worth $500,000, was lost. Quick action by New Haven firefighters brought the fire under control in 50 minutes. A large crowd gathered in the area as the afternoon fire snarled rush-hour traffic. (Photograph by Mara Lavitt.)

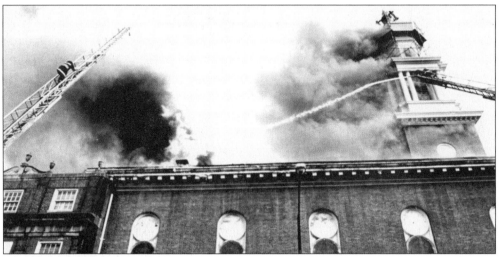

Using aerial ladders and water towers to reach the flames, firefighters battled the four-alarm blaze at the First and Summerfield United Methodist Church in downtown New Haven. Attacking the blaze from the interior, firefighters inched their way along the attic area and were able to contain the flames before they could engulf the inside of the structure. The church was saved from total destruction by the gallant efforts of New Haven's bravest. (Photograph by Mara Lavitt.)

A spark from a cutting torch triggered a stubborn, sooty oil fire in an abandoned natural-gas tank on Chapel Street in Fair Haven on December 5, 1987. It took firefighters three hours to extinguish the blaze. Workers who had been cutting into the 230-foot-high tank to prepare it for demolition accidentally ignited a thick layer of oil sludge on the bottom of the tank. The fire flashed over into a fireball. Many firefighters working the blaze were treated by medics for irritated eyes, exhaustion, or nausea. Lt. James Martens of Tactical Unit No. 2 prepares to move back into the battle with his Scott Air Pak breathing equipment. This photograph appeared on the front page of the *New Haven Register* and was taken by photographer Kirby Kennedy. It won a first prize in the media awards contest sponsored by the International Association of Firefighters.

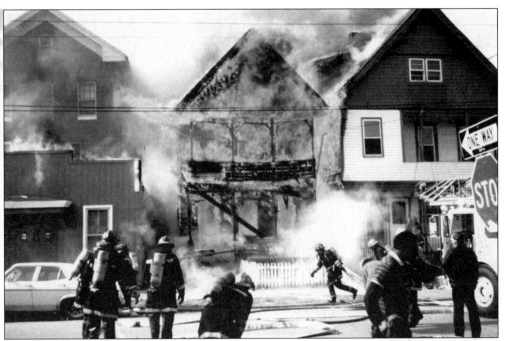

On March 4, 1989, a four-alarm fire ripped through three multifamily houses on Cedar Hill Avenue, leaving one man dead and 67 people homeless. Deputy Chief George Ehrler, who directed the early operations at the fire, suffered a heart attack, and two other firefighters were injured. The fire initially raged out of control because a vandalized hydrant near the structure could not be opened. Many residents from the three buildings were rescued by neighbors and firefighters.

Firefighters assigned to the Dixwell Fire Station, located at Goffe and Webster Streets, find time for a quick photograph on February 15, 1990. The men standing in front of Engine Company No. 6 are, from left to right, as follows: (front row) Lt. Charles Holness, Charles Hewitt, Kevin Delaney, James DeCresenzo, Dennis Sweeney, Lou Bosley, Mark Harrison, and Lt. Kevin Miller; (back row) Thomas Neville, Thomas King, and Leonard Wishart.

On June 26, 1990, Chief John P. Reardon retired after leading the department for 12 years. Under Reardon's leadership, the computerized Arson Warning and Prevention Strategy (AWPS) was developed and used as a model for tracking structures at risk to arson-for-profit schemes. His proactive fire-prevention mode resulted in a dramatic decrease in structural fires and the demise of arson for profit. Under Reardon's watch, the hazardous materials unit was established, and the apparatus-replacement program provided a modern fleet of equipment and safer tools for the firefighters. A new fire station was erected in the Hill neighborhood; the New Haven Regional Fire Training Academy rose on the banks of the West River; and the administrative and firefighters' quarters at the department's headquarters were renovated, giving the office of the fire marshal adequate office space and computers. Also, a third battalion was activated, and a fourth emergency unit went on duty to meet the rising demand for emergency medical service.

# Chief of Department

**CHARLES W. ALLEN**
*June 24, 1862 – July 8, 1865*

**ALBERT C. HENDRICKS**
*July 24, 1865 – January 31, 1892*

**ANDREW JACKSON. KENNEDY**
*1892 – September 3, 1897*

**WILLIAM HIRAM HUBBARD**
*September 4, 1897 - August 29, 1898*

**RUFUS R. FANCHER**
*September 1, 1898 - November 18, 1925*

**LAWRENCE E. REIF**
*December 31, 1925 - December 31, 1940*

**PAUL P. HEINZ**
*January 1, 1941 – December 30, 1953*

**THOMAS J. COLLINS**
*December 31, 1953 - June 30, 1965*

**FRANCIS J. SWEENEY**
*July 1, 1965 - August 30, 1978*

**JOHN P. REARDON**
*October 5, 1978 - June 26, 1990*

**EARL D. GEYER SR.**
*July 19, 1990 - June 30, 1992*

**JOHN E. SMITH**
*July 7, 1992 - February 6, 1996*

**MARTIN J. O'CONNOR**
*February 7, 1996 – January 20, 1998*

**DENNIS W. DANIELS**
*February 2, 1998 – December 31, 2002*

**MICHAEL GRANT**
*January 27, 2003 - Present*

Since 1862, the head of the New Haven Fire Department (chief engineer, chief) has been appointed to that position by the mayor of New Haven in accordance with the city charter. Over the years, the choice has been made from the ranks of the career fire department. It is a tribute and a show of confidence to the leadership that during a span of 142 years, only 15 firefighters have headed up the fire department.

# Lest We Forget – In The Line of Duty

**Volunteer Bevil Sperry**
*October 24, 1852*

**James T. Hemingway**
*June 15, 1852*

**James B. T. Benjamin**
*January 1, 1858*

**William Miles**
*February 9, 1858*

**Harry M. Brooks**
*May 14, 1878*

**Edwin L. Hubbell**
*July 4, 1888*

**George A. Dennison**
*January 26, 1893*

**Walter P. Hovey**
*July 12, 1899*

**Jeremiah F. Regan**
*November 20, 1899*

**Captain Joseph Condren**
**William Reilly**
**Frederick W. Hale**
**Frank Williams**
*February 19, 1901*

**Joseph P. Robert**
*August 7, 1906*

**Lieutenant Frank Conlan**
*May 2, 1908*

**Captain Charles Chapman**
**Lieutenant William Dougherty**
**John E. Buckley**
**James Mortel**
**Thomas J. McGrath**
**James Cullen**
*April 13, 1910*

**James F. Weldon**
*May 11, 1918*

**Frederick Cofrancesco**
*November 26, 1924*

**George Porter**
*July 10, 1925*

**Thomas J. Durkin**
*October 24, 1925*

**Henry G. Eckert**
*October 3, 1927*

**Edward P. Hermance**
*November 23, 1928*

**William Cleary**
*January 8, 1930*

**William Richardson**
*March 27, 1931*

**Lieutenant William J. Langan**
*November 21, 1932*

**Captain Irving A. Hamilton**
*August 15, 1934*

**Richard R. Lyons**
*November 18, 1936*

**Captain Thomas J. Delaney**
*August 10, 1937*

**Eugene F. Sullivan**
*September 25, 1937*

**Thomas F. McCurry**
*February 5, 1938*

**John M. McGarry**
*March 9, 1941*

**Captain Sylvestor J. McNerney**
*October 16, 1941*

**Ernest A. Koelle**
*March 10, 1943*

**Deputy Chief William J. Killoy**
*December 5, 1946*

**Anthony Kuziel**
*November 23, 1952*

**Captain Edward T. Turbett**
*December 15, 1953*

**Assistant Chief George F. Lynch**
*June 1, 1954*

**William T. Carey**
**Charles Mauro**
*February 14, 1959*

**Walter F. Moore**
*May 26, 1963*

**Raymond McKiernan**
*January 31, 1964*

**Captain William Greene**
*January 30, 1966*

**Thomas Langley**
*May 10, 1967*

**Lieutenant James Dillon**
*December 4, 1967*

**Inspector Frank Coppola**
*November 14, 1971*

**John D. Mitchell**
*October 8, 1974*

**Thomas C. Harvey**
*February 5, 1975*

**Robert D. McLean**
*January 27, 1977*

**Marion E. Robinson**
*June 4, 1977*

**Lieutenant Francis R. Foley**
*October 13, 1979*

**Captain Allan J. Turner**
*October 9, 1981*

**Henry Savage**
*April 28, 1982*

**Battalion Chief Leonard Guerrera**
*January 16, 1984*

**Captain Anthony L. Conforte**
*January 19, 1984*

New Haven has had many sad moments in fire department history. "Lest we forget," some 59 men have died in the line of duty. Many of the deaths were suffered on the fire ground or while responding to our citizens' call for help. A plaque on a large painted mural at the New Haven Fire Training Academy is dedicated to their memory.